THE CINCINNATI REDS
1900–1950

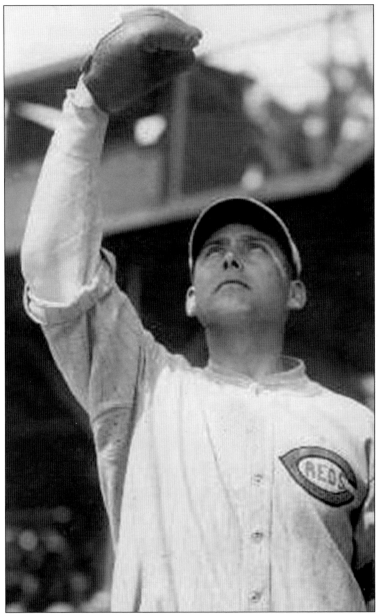

Edd Roush, the Reds' exemplary center fielder, played for the team from 1916 to 1926, and again in 1931. Roush had a career batting average of .331 in a Reds uniform and slugged 152 triples in the dead ball era. He came over to Cincinnati in a deal with the New York Giants, which also included famed pitcher Christy Mathewson (who replaced Buck Herzog as manager), and infielder Bill McKechnie (who two decades later would manage the Reds to two World Series).

THE CINCINNATI REDS
1900–1950

Kevin Grace

ARCADIA
PUBLISHING

Published by Arcadia Publishing
Charleston SC, Chicago IL, Portsmouth NH, San Francisco CA

Printed in the United States of America

Library of Congress Catalog Card Number: 2005924392

For all general information contact Arcadia Publishing at:
Telephone 843-853-2070
Fax 843-853-0044
E-mail sales@arcadiapublishing.com
For customer service and orders:
Toll-Free 1-888-313-2665

Visit us on the Internet at www.arcadiapublishing.com

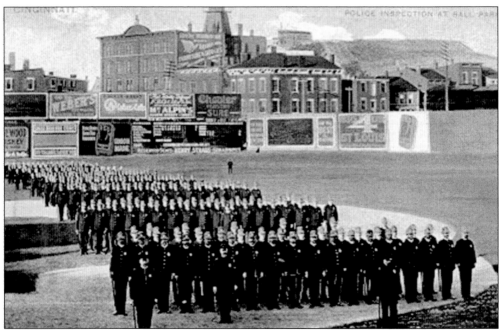

As with most urban ballparks during baseball's first great stadium building phase in the early 1900s, Cincinnati's Palace of the Fans was host to more than Reds games. It served as a community space as well, hosting boxing and wrestling matches, political and religious rallies, and the occasional parade or revue, as shown in this postcard of the Cincinnati Police Department using the field.

CONTENTS

ACKNOWLEDGMENTS

This book is dedicated to Thomas Scherz and Minh Dang, whose technical expertise rescued this book when I sent it to cyber oblivion.

Thank you to Jack Klumpe, Stuart Hodesh, every member, in one way or another, of the Society for American Baseball Research, and my students in the Social History of Baseball at the University of Cincinnati—over the years each one of them has taught me something new about the place of baseball in American society. And, many debts are due to Jeff Ruetsche of Arcadia Publishing, Anna Heran, Don Tolzmann, Tom White, and Kate Barone.

As always, I offer my thanks and appreciation to my wife, Joan Fenton, and my children, Bonnie, Lily, Sean, Courtney, and Josh.

INTRODUCTION

In 1909, Garry Herrmann had the world by the tail. The city of Cincinnati was exhibiting itself as one of the major sports centers in the country, and the president of the Reds was a large part of that success. Just the previous year, in 1908, Herrmann brought the American Bowling Congress' national tournament to the Queen City, turning the Freeman Avenue Armory into a bowling venue, complete with a German rathskellar in the basement. He then turned his attention to experimenting with lights for night baseball at the Palace of the Fans. In '09 that experiment was realized, and though Herrmann decided that such an innovation in Major League baseball needed more tinkering, it came on the heels that June of the national *turnfest* in Cincinnati, a quadrennial "Olympiad" of sorts that brought German-American athletes from around the country to compete in track & field events. Herrmann was in charge of that event as well.

The first decade of the twentieth century saw Organized Baseball become an established business and sporting enterprise. The American and National Leagues ended a brief war of competition for fans, players, and franchises when Herrmann mediated a peace agreement in 1903. Accords were put into place that prohibited the jumping of contracts by players, and instituting standard rules of play. And, the modern World Series was played for the first time after the '03 season, with Herrmann receiving credit for its creation to the point where he has sometimes been termed the "Father of the World Series." Because of his successful handling of the negotiations, when the National Commission triumvirate was formed to govern the Major Leagues with the American League and National League presidents along with one owner as the members, Herrmann was chosen as the representative of the owners. Since his vote would always be the deciding one in baseball matters, he became the *de facto* commissioner of baseball.

Over the first 50 years of the 1900s, the Cincinnati Reds exerted a considerable influence on baseball affairs. On the playing field, they were only occasionally above average. But with Herrmann's influence and control in baseball affairs; their experimentation with lights, and then using them on a regular basis; their use of radio broadcasts of their games and air flight for travel; and the groundskeeping innovations of Matty Schwab all had wide-reaching effects on baseball. And, the fact that they played in one of the most infamous sporting events of all time—the 1919 World Series, that they had a pitcher who hurled two consecutive no-hitters, and another pitcher who debuted at the tender age of 15, kept the Reds on the scroll of notable moments.

The period of 1900 to 1950 is when America really came into its own as a sports nation. Following on the ideals of the Progressive Era (roughly 1880 to 1920) that saw efforts toward

civic betterment and clean government, community needs-oriented educational policies, and attempts to end vice, corruption, and urban squalor, athletics had an increasingly important place. A fit body with a fit mind helped forge the character that made a fit citizen. YMCA gyms were constructed. Playgrounds and recreation halls were built, and college athletic programs developed beyond the beginnings of football, track, and baseball in the nineteenth century to encompass a variety of sports for both male and female students. In professional sports, baseball, boxing, and horse racing were the primary attractions. Newspapers devoted more and more coverage to sports, particularly baseball. Organized Baseball developed its creation myth of a Cooperstown birth in 1839, "Take Me Out to the Ballgame" became its signature song, and the game truly did become the "National Pastime."

In the 'teens, however, things took another direction. Herrmann was increasingly under fire from the other team owners for decisions he made as Chairman of the National Commission. Gambling, which had always been around sport—and baseball since its beginnings nearly a century ago—became rampant in the game. World War I and the devastating Spanish Influenza that followed added to baseball's woes. The 1919 series only served to throw the game into disarray, and Prohibition did no one any good, particularly for the teams that relied on alcohol sales as a substantial part of their concession income.

But the 1920s—the Roaring '20s—was the so-called "Golden Age of Sport." Babe Ruth rescued baseball with his home runs and personality, a new commissioner assumed autocratic control, and life seemed good. Jack Dempsey was the heavyweight champ, Red Grange took football to new levels of popularity, and even a French social philosopher named Emile Coue introduced "Positive Affirmation" in which Americans told themselves they were valuable individuals through little statements of self-worth they could recite throughout the day—"Every day, in every way, I am getting better and better."

Even through the Great Depression and another World War, Americans embraced baseball as something special in the national culture. And the Cincinnati Reds? They were a part of all of it. Three times during the first half of the 20th century, the Reds would pull themselves from the bog of mediocrity into solid championship form. Three times they won the National League pennant, in 1919, 1939, and 1940, with World Series championships in '19 and '40. And though the sentiment about the tainted 1919 world title had the Reds as dubious victors over the vaunted Chicago White Sox, today baseball historians generally acknowledge that the Reds in 1919 were a considerably talented team as were the Sox, and the two teams—thrown games or not—were well-matched.

The Reds have always been a reflection of their city and their fans. The fan base may extend 200 miles in every direction from the ball field but it comes down to the heritage of a National League team that is in the thick of baseball culture, and inseparable from the heart of the Queen City. History and culture are appreciably better when there is a visual context to provide a texture and understanding of the past. So to borrow a line that my late grandfather-in-law, Ellis Rawnsley, was fond of quoting from his favorite author, Jerome K. Jerome: "The events described really happened. All that has been done is to color them, and for this no extra charge has been made."

8

ONE

Baseball and the Reds on Top of the World
1900–1909

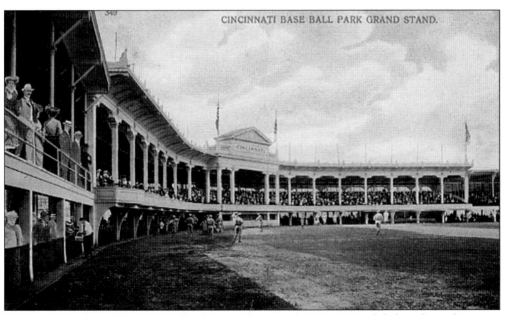

Cincinnati's Palace of the Fans ballpark opened on April 17, 1902. Modeled on the architecture seen at the 1893 World's Fair in Chicago, the "new" ballpark was really just the main grandstand behind and around home plate, complete with beautiful pillars and scalloped opera-style box seats. The Reds lost to the Chicago Cubs that opening day, 6–1, and on the official dedication day on May 16, lost to the New York Giants, 5–3.

John T. Brush, the owner of the Reds at the turn of the 20th century, was a department store owner in Indianapolis, and thus absent most of the time from his team and ballpark. He had owned a team in Indy that was more or less squeezed out of the National League, and in 1891 he purchased the Cincinnati Reds, who were about to be taken back into the league after a decade-long absence. In August of 1902, Brush sold the Reds to a group headed by local political boss George Barnsdale Cox, industrialists Julius and Max Fleischmann (of gin and yeast fame), and Cox politico, August "Garry" Herrmann. He then purchased the controlling interest of the New York Giants.

Shown in a newspaper cartoon with a parade of players marching by, Reds business manager Frank Bancroft was the man who really operated the club on a daily basis. Bancroft saw to the upkeep of the ballpark, made player trades, and took care of contracts. In short, he was the front office face of the team. Bancroft first joined the Reds in 1892, under Brush, and ended his career in 1920, under Garry Herrmann. He is also credited with creating the local tradition that has become the Opening Day celebration in Cincinnati.

Bob Allen only managed one season in the Major Leagues, for the Reds in 1900. A former shortstop for the National League's Philadelphia and Boston teams, Allen was mediocre as a manager, leading the Reds to a 62-77 record, playing in five games himself. Still, he did have some outstanding stars of the era on that team, including Jake Beckley, Sam Crawford, Frank Hahn, and Harry Steinfeldt.

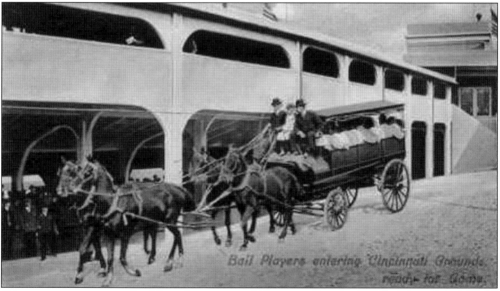

Often visiting teams in the Major Leagues would have to dress in their hotel, and then make their way to the ballpark in their uniforms. Visiting team locker rooms were still a feature of future stadium construction. It did, however, give the neighborhood and the fans a chance to see the foe of the day. This image shows a horse-drawn "bus" carrying a team to the Palace of the Fans. Sheds were provided at the ballpark for the carriages, but within only a few years, the available spaces were being used for automobiles.

In 1899, Frank Hahn began his pitching career with the Reds in splendid fashion, winning 23 games against only 7 defeats. For the next seven years, he was the best hurler on the Reds staff, reaching 20 wins in four of those years, and finishing his Cincinnati tenure with a record 126-90, including a no-hitter in 1900. His arm finally gave out in 1906. Earning a degree in veterinary medicine during his career, the doctor was better known as "Noodles" Hahn. Only bluesmen and boxers have better nicknames than baseball players.

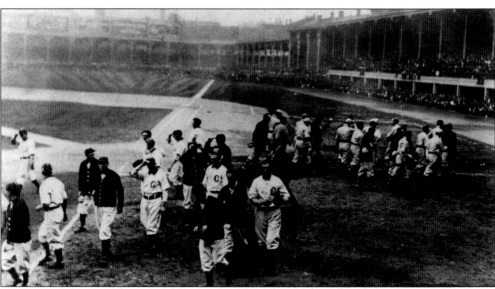

For most of its existence, the Palace of the Fans still went by the old ballpark name of League Park. Though the new stadium featured a more elaborate façade and grandstand, it was still a very basic 19th century park. Since the sale of beer and whiskey was a nice source of concession revenue by this time, one notable aspect of the field was "Rooters Row," a chicken-wire enclosed section of field-level seats that protected the players from the abuse of drinking fans—and in turn protected fans from angry ballplayers.

Julius Fleischmann was the scion of a distilling and yeast fortune that had been built by his immigrant father. A prominent Jewish-German businessman, Julius raised himself to considerable influence in the local Republican Party through his alliance with Boss George Cox. From 1900 to 1905, he served as Cincinnati mayor, with Cox peddling patronage and power from behind the scenes. Julius Fleischmann was also a local benefactor of some note as well, lending his presence and money to a variety of civic and charitable causes. In 1902, he fronted the money for a new ownership group to purchase the Reds from John Brush.

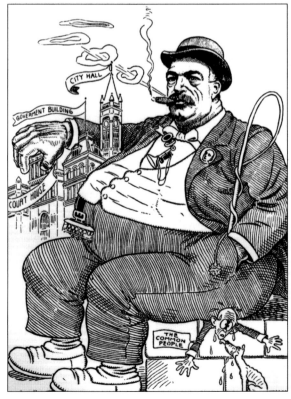

George Barnsdale Cox was a man who had made it on his own guts and initiative. Born of English immigrant parents, Cox was orphaned at the age of eight, and thrust out on his own. As a boy, he worked as a bootblack and a gambling den lookout, and as an adult, he bought the Mecca Saloon in the West End. It was here that he consolidated his power in local politics, eventually leading a coalition of local Republicans and solidifying his hold on City Hall and the Hamilton County Courthouse. While he used his civic connections to help buy the Reds, Cox was content to remain in the background when it came to baseball affairs.

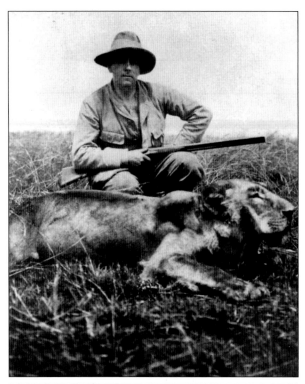

After the purchase of the Reds from Brush, Cox and Julius Fleischmann put Julius' brother Max in charge of the club. Herrmann was named president and was to report all financial operations to Max, who served as treasurer. However, Max was never inclined to daily office life. His interests ran more to big game hunting, yachting, traveling about, and generally living the life of a gentleman sportsman. Herrmann duly consulted him on budgets and expenditures, and Max duly gave his various opinions and sign-offs. But he was usually elsewhere in the world. The top photo shows Max Fleischmann from his 1909 book, *After Big Game in Arctic and Tropic*, and the bottom image is of another Max's diversions, ballooning.

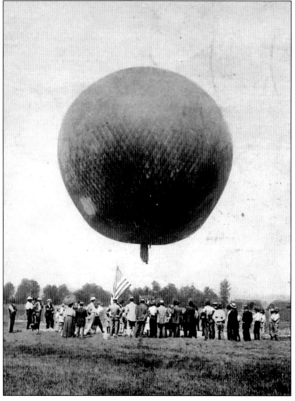

August "Garry" Herrmann ran the club on a day-to-day basis, reporting to Max. Political right hand man to Cox, Herrmann operated the Reds much as he had operated City Hall for the machine, knowing when to extend the glad hand and when to wield the heavy hand. The good-natured aspect of baseball was perfect for a politician to garner favor among the voters. Herrmann's astute use of mediation, common sense, and male camaraderie also led to the end of the "war" between the American and National Leagues in 1903. Herrmann hosted club owners at Cincinnati's St. Nicholas Hotel that January, and kept them there until agreements were reached on territories, rights to players, uniform playing rules, and non-conflicting schedules. A reporter for *Sporting Life* wrote,

"Without Herrmann's personality and reputation for fair dealing it is doubtful if anything would have come of the conference. . . . The visiting conferees were unanimous in saying that Garry Herrmann led them into the promised land. . . ."

St. Nicholas Hotel
Young and Carl, phot.
68. - CINCINNATI (Ohio)
Handcolored

15

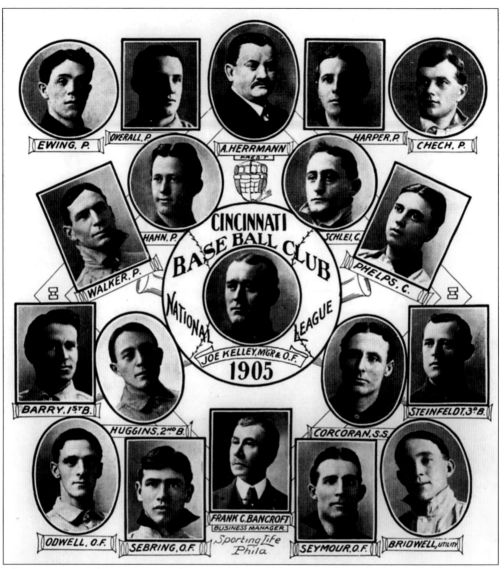

EWING, P. OVERALL, P. A. HERRMANN PRES'T HARPER, P. CHECH, P.

HAHN, P. CINCINNATI BASE BALL CLUB SCHLEI, C. PHELPS, C.

NATIONAL LEAGUE

JOE KELLEY, MGR & O.F. 1905

WALKER, P.

BARRY, 1ST B. HUGGINS, 2ND B. CORCORAN, S.S. STEINFELDT, 3RD B.

ODWELL, O.F. SEBRING, O.F. FRANK C. BANCROFT [BUSINESS MANAGER] Sporting Life Phila SEYMOUR, O.F. BRIDWELL, UTILITY

The 1905 team photo prominently featured Herrmann at the top. It wasn't a bad team, but lack of reliable pitching—the sore-armed Noodles Hahn would be released by the Reds in August—saw the team finish fifth with a 79–74 record.

James Bentley "Cy" Seymour was the hitting star of the team. The Reds outfielder knocked in 121 runs in 1905, and hit for an average of .377, still the team record. He even hit two inside-the-park home runs in one game, a September 24 win over the Dodgers, 8–3. Seymour played for Cincinnati from 1902 to 1906 and over a 16-year career in the Major Leagues, he batted .303 and had over 1700 hits.

Miller Huggins, variously called "Mighty Mite" and "Little Mr. Everywhere" for his diminutive size, was an outstanding infielder who graduated from Cincinnati's Walnut Hills High School. Enrolling in the University of Cincinnati's College of Law, Huggins had to appear before the faculty more than once to explain why he should not be dropped for poor grades and attendance. Often he missed class because he was either playing minor league baseball or for the university team. He persevered, however, and graduated with a law degree. Perhaps that had something to do with his taking a role in his own destiny at a time when players had very little input into their own contracts. Playing in the minor leagues, Huggins wrote to Garry Herrmann in 1903: "Mr. Herrmann, I would gladly do business with you for next year at this time if my mind was clearly made up to leave St. Paul." Apparently it was. Huggins played for the Reds from 1904 through 1909.

REMARK CARD OF _Huggins Miller_

⅔98 Permitted to drop French &

⁶/₁₁ 98. Required to appear before the Ex. Com. & show cause why he should not be dropped. ⁹/₉₅ Required to repeat in class all work in which he was conditioned.

⁶/98 required to postpone Latin 2 ³/₁₀ 99 Req to show cause why he should not be dropped

UNIVERSITY OF CINCINNATI. ACADEMIC YEAR, 189 -9 .
Form 5.

In 1905, a satirical book of caricatures was published about Garry Herrmann and the previous, 1904, season. Titled *The Garry*, the book took a day-by-day review of the year. In the first image, manager Joe Kelley is explaining the spitball to Herrmann, who backs away from the "shower." As Kelley explains to his boss, pitchers who drink can't use the spitball because they are always "dry." In the bottom image, the machinations of baseball's moguls are shown as Herrmann (right) bargains with Pirates owner Barney Dreyfuss (left) and Giants owner John Brush (center) as they clutch their little ballplayers. Dreyfuss, with whom Herrmann regularly feuded, is shown in the caricature stereotype of the time of an avaricious Jewish businessman. It was said that Herrmann disliked Dreyfuss so much that in 1906 the Reds traded star outfielder Cy Seymour to the Giants halfway through the season in order to thwart the Pirates' drive for the pennant and help the New York club finish ahead of them in the standings. Both were well outpaced that year by the Chicago Cubs.

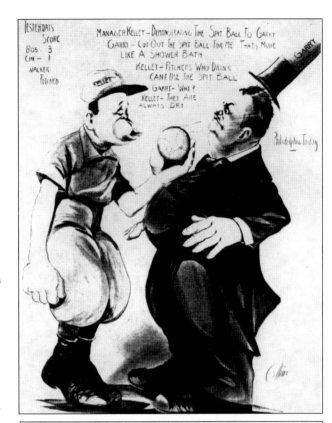

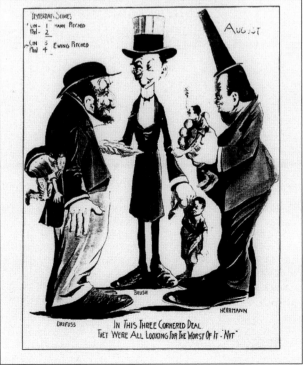

Garry Herrmann was a perfect model for newspaper cartoonists and other caricaturists. His florid face and small moustache, coupled with his loud clothes and ostentatious jewelry, made him seem a clown at times, but he was always eminently newsworthy. The caricatures often lampooned a man who was also a solid politician and businessman. He was devoted to his German roots, and many of the cartoons played upon this heritage along with the fans he attracted to the ballpark. It was only a generation before, in 1880, that the Reds had been kicked out of the National League for the dastardly policies of selling alcohol and playing games on Sunday, both ethnic German customs. Their re-admission in 1892, after a decade in the American Association, the so-called "Beer Ball League" came with the team standing strongly in defense of Sunday games and lager, something Herrmann continued with gusto.

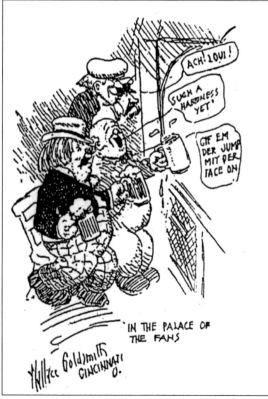

These two picture postcards of the Reds at the Palace of the Fans show the players on the field. One can only hope that in the bottom photo, the player behind the small bulls eye also had a glove to protect himself!

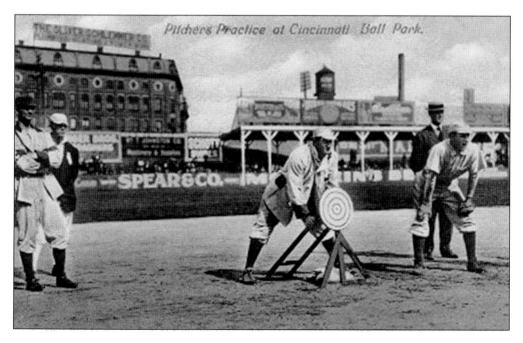

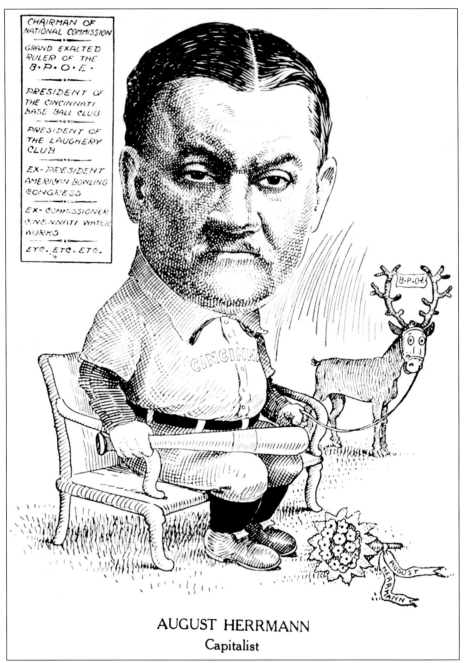

AUGUST HERRMANN
Capitalist

Garry Herrmann was a lot like his mentor, George Cox, in that he too was orphaned at a young age and worked hard to build a career in the public eye. Through political patronage, he served on the Waterworks Commission, the Board of Education, and the Board of Administration, ultimately having his hand in every aspect of city government. He was also a joiner, particularly when it came to the Elks, for which he served as Grand Exalted Ruler, and German-American societies like the Turners. In addition to his presidency of the Reds, and his role as the leader of the 1909 national *Turnfest* of German-American athletics, Herrmann was also a president of the American Bowling Congress, bringing the annual tournament to Cincinnati in 1908.

On June 18, 1909, Garry Herrmann put into action a plan for night baseball on which he had been working since the previous year. He formed the Night Baseball Development Company and spent $50,000 for lights. An exhibition game was to be played between the Reds—who had beaten the Phillies 4-1 in an afternoon game—and a local amateur team. However, Herrmann had cold feet about using his professionals, so instead he used his Elks influence and had two local Elks teams play the game. The Cincinnati team beat the Newport, Kentucky team, 8-5, but with 18 errors that night, Herrmann put off any further experimentation.

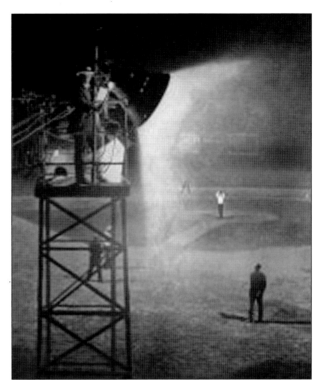

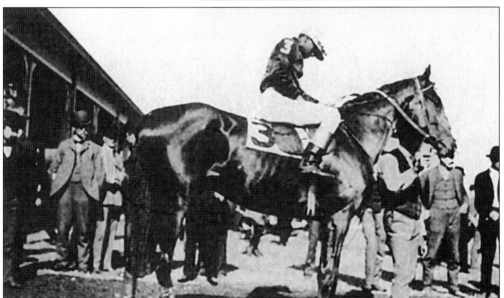

Herrmann's involvement in sport extended to the "sport of kings" as well. His reputation in athletics was such that a noted racehorse was named for him. In this image, Kentucky Derby champion jockey Jimmy Winkfield is shown atop the equine Garry Herrmann in a Memphis race in 1900. The horse was called "the best of the West," and at one point held the record for a mile and 50 yards. Three years after this photo, the great Winkfield was blackballed from American racing because he was African American; the heritage of the great Black jockeys who had helped form America's racing tradition were victims of Jim Crow policies.

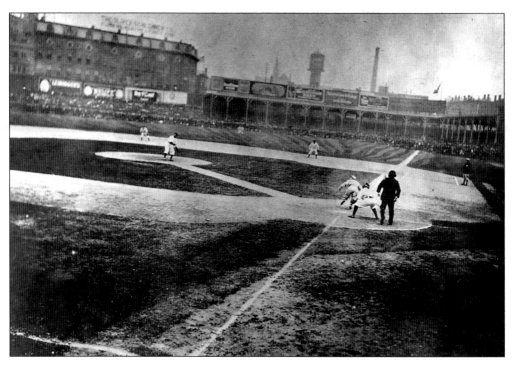

Here are two early views of the Palace of the Fans. During the first ballpark building boom of the early 20th century, baseball parks were seen as the important civic equivalent of massive train stations, churches, new factories, and libraries. It was a mark of local pride and municipal character to have a grand, new ballpark, and the Palace fit the bill for Cincinnati.

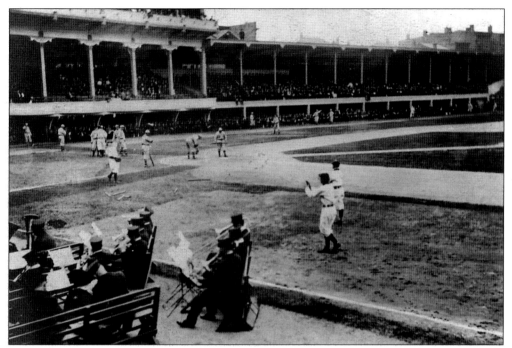

The ballpark was a big part of local life. The festivities in this image included an orchestra playing while the Reds warmed up before the opening game.

One of the speediest Reds of all time was outfielder Bob Bescher, who played for Cincinnati from 1908 through 1913, before being dealt to the Giants. In 1911, Bescher swiped 81 bases, a National League record that would stand for over half a century. The former Notre Dame University ballplayer was also one of the few players with some college education at the time, though as the decade passed, there were more and more major leaguers who spent some time at a university.

A gentle man when he was sober, catcher Larry McLean was ferocious when he was drunk, and that was quite often. He was a huge man by the standards of the day, standing six feet, five inches tall and weighing 230 pounds. He was a pretty fair defensive catcher on the days he made it to the ballpark, but eventually his drinking and brawling caught up to him. Traded to the Cardinals in 1913, and then very quickly to the Giants, he was out of baseball after 1916. Even during Prohibition he found his drink, and in 1921 when he started a fight in a "near beer" Boston saloon, the bartender shot and killed him.

Cincinnati sports writer Ren Mulford was one of the first local journalists to direct his coverage of the Reds beyond the daily scores to exploring the entire history of baseball in the city. He assisted Harry Ellard in writing his 1907 book on Cincinnati balldom, and took a somewhat "purist" approach to the game—literally. At a time when the spitball and other doctored pitches were legal (it wouldn't be until 1920 that they were outlawed), Mulford weighed in on the unsanitary nature of the pitch: "There is nothing very pleasant in the sight of a big fellow emptying the contents of his face upon a ball. There's something creepy and slimy in the very suggestion of the spitball. It is a slobber-coated sphere."

TWO

A World of Gambling and the Great War
1910–1919

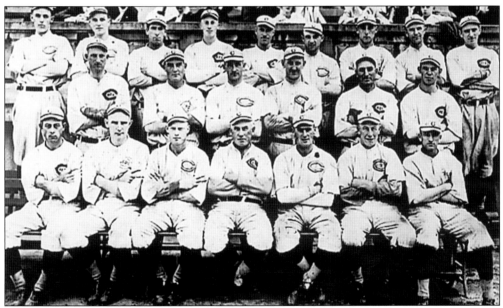

The 1919 Cincinnati Reds were a team destined for infamy by association. Their victory over the Chicago White Sox in the World Series would be questioned by the knowledge that seven of the Sox conspired to throw games in exchange for payoffs from gamblers. However, they were a very good team at nearly every position, and managed by Pat Moran they won the National League pennant with 96 victories, nine games ahead of the second-place Giants.

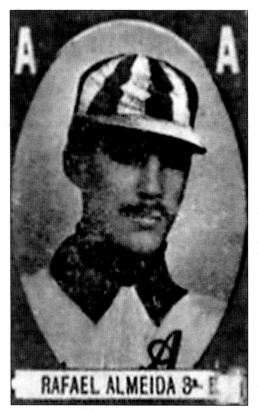

RAFAEL ALMEIDA 3ᴬ. E

On July 4, 1911, two Cuban-born players joined the Cincinnati Reds. Rafael Almeida (top) was an outstanding third baseman in Havana, and Armando Marsans (bottom) was a star outfielder. The Reds initially saw the players when the team toured Cuba in 1908 during a barnstorming exhibition schedule. However, the club had to make a sell to the public on the notion of two dark-skinned foreigners on the team. Marsans and Almeida represented the second and third Cuban-born players in big league baseball, following Esteban Enrique Bellan on the Troy Haymakers of the National Association of Professional Base Ball Players in 1871—forty years prior to their debuts.

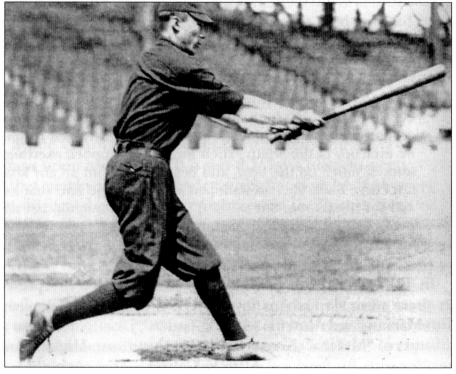

The cartoon below shows how newspapers played on the Latin American heritage to portray the players as bullfighters. The public relations stance of the Reds was that the two Cubans were nobly born and were of Spanish aristocratic heritage rather than being of mixed race. One early news piece even stated they were as "pure as a bar of Castilian soap." Marsans (right) had the more substantial career, playing for eight years including a stint with the St. Louis entry in the short-lived Federal League. Jumping his contract with the Reds led to a lawsuit in which Herrmann contended Cincinnati was entitled to damages since they had spent the money developing him as a player. As for Almeida, he had a short, but colorful, three-year career. The 1910 Reds scouting report on his minor league tenure with the New Britain club said: ". . . stopped at hotel at Hartford, claiming New Britain hotel not good enough for him." A 1912 article stated that he arrived in Cincinnati with his own valet, and claimed that he could not be expected "to play good ball without my own brand [of cigars] to smoke."

For as attractive as the Palace of the Fans was, within a few short years of its construction, it wasn't bringing in nearly enough revenue for the Reds' owners. The team's popularity continued to grow, and more box seats—the premium, costly seats—were needed. On the heels of a fire that destroyed part of the grandstand, the club decided to construct a new ballpark so after the 1911 season ended, demolition crews went to work. The new ballpark, to be called Redland Field, was the design of Cincinnati architect Harry Hake. Hake had important ties to the Republican Party, which in turn brought him many commissions, including for a team owned by prominent Republicans. Hake designed the Hamilton County Courthouse, several police and fire stations, and buildings for the University of Cincinnati, a municipal institution at the time. Redland Field, a common nickname since the days of League Park, opened on April 11, 1912.

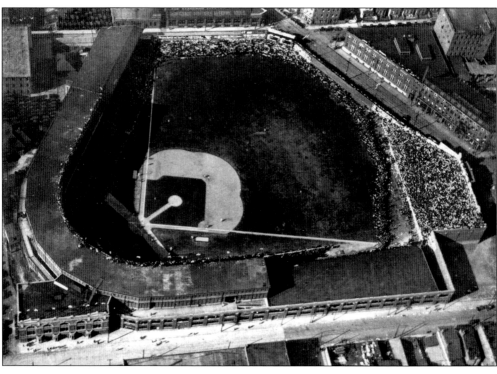

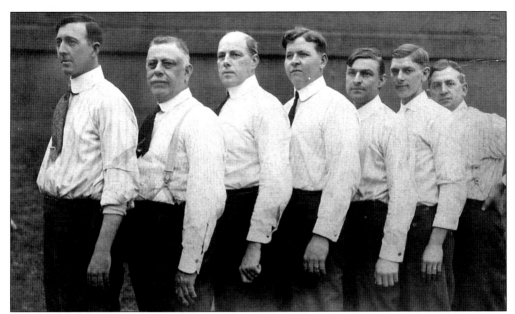

The head groundskeeper of Redland remained Matty Schwab, pictured here with his crew, third from the left. An employee of the Reds since1894, Schwab worked for the team until 1963. It was he who created the famous terrace in left field, designed the center field scoreboard, and created innovative tools like infield-dragging equipment, the latter so popular that in 1911, a Japanese university barnstorming team took the design back for use in their own country.

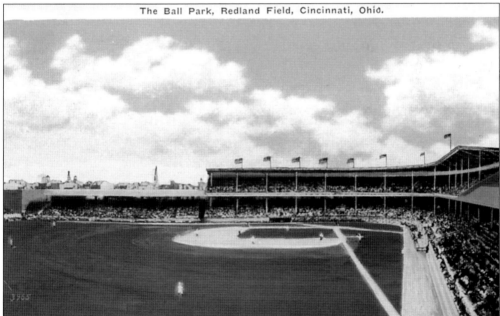

The Ball Park, Redland Field, Cincinnati, Ohio.

Redland Field was one of the largest ballparks in the Major Leagues, with the outfield distances 360 down the left field line, 400 feet down right, and 420 feet to straightaway center field. As long as the outfielders didn't play too closely in, it was a pitcher's park. But for those fielders who left too much turf behind them, there were a great many extra-base hits. The scalloped infield designed by Schwab aesthetically replaced the scalloped box seats of the Palace.

31

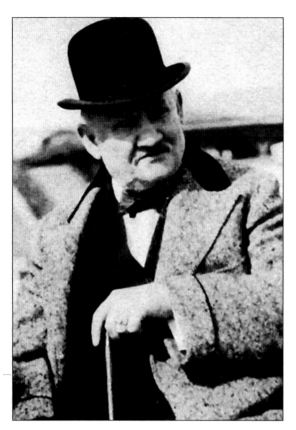

Garry Herrmann, like other sporting entrepreneurs, sought to realize more revenue from their facilities than the main sport earned. So, the inestimable Garry leased the ballpark for the standard boxing and wrestling matches, but also for movies and dances. In 1921, however, he received a letter from Frank Nelson, the president of Cincinnati's Juvenile Protective Association: "Gentlemen: The Board of Directors of the Juvenile Protective Association wishes to call to your attention the conditions prevailing at Redland Field…[We] have observed there, this season, immoral dancing of the most extreme type…The whole atmosphere—including the vulgar conduct which we have observed between girls and men in the unlighted portions of the grand-stand—is questionable and presents a dangerous situation." The group allowed that better lighting for movies could eliminate such conduct, but asked that the dancing "privilege" (or concession) be cancelled.

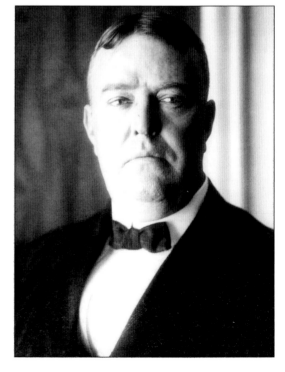

American League president Ban Johnson was one of the three National Commission members, and a close supporter of Herrmann. Friends since Johnson's day as a sportswriter in Cincinnati before he began the Western League and transformed it into the American League, the two often agreed on Major League policies and issues. While Herrmann was originally perceived as fair and impartial, as decisions went against National League owners and seemed to favor Johnson's AL, support for the commission began to fade.

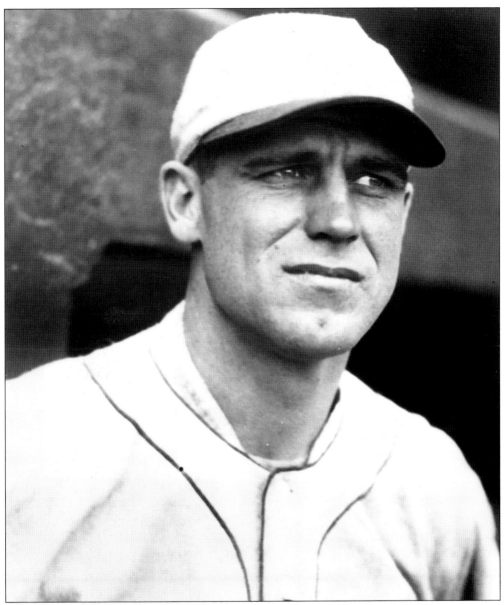

Probably the big break in support came when Herrmann was faced with a dispute between the National League Pittsburgh Pirates and the American League St. Louis Browns. Each team claimed the services of first baseman George "Gorgeous George" Sisler, who had signed contracts with both teams after he came out of the University of Michigan in 1915. Barney Dreyfuss, the owner of the Pirates, and Herrmann had a long-running feud between them that dated back more than ten years. Though cordial in correspondence and official matters of the game, in private they intensely disliked each other and it was Dreyfuss who most often took issue with Herrmann's tiebreaking votes on AL–NL disputes. In the Sisler matter, Herrmann ruled in favor of the American League, deciding that the contract Sisler signed with the Browns took precedence over the Pirates contract. Sisler went to the Browns, and became one of the greatest first basemen in baseball history. Over a fifteen-year career, he batted .340 and was elected to the Hall of Fame in 1939.

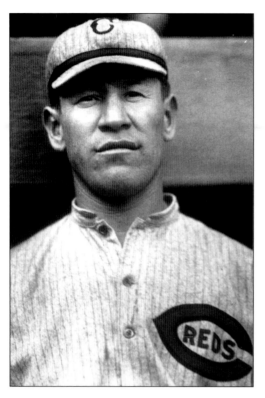

One of the greatest athletes of the twentieth century, Jim Thorpe as often referred to as a "physical paragon." A member of the Sac and Fox Indian tribe, Thorpe was educated at the Carlisle Indian School in Pennsylvania, and at the 1912 Stockholm Olympics, he won both the decathlon and pentathlon. American Indian boarding schools like Carlisle included athletic programs in order to muster political and financial support, and to show off the students and how well they "assimilated" into white American life. For Thorpe it was the beginning of a sports career. His Olympic medals were stripped from him when it was discovered he had played a season of minor league baseball. It's too bad—that season certainly didn't make him a great baseball player. Thorpe played six years in the Majors, but was never better than mediocre, including the 1917 season with Cincinnati when he batted .247. He was much better as a professional football player with the Canton Bulldogs in the 1920s.

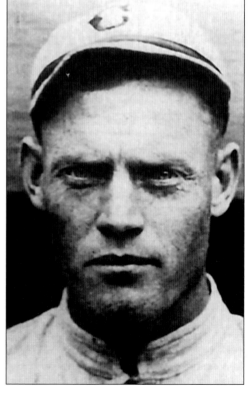

In 1915, the Reds obtained hard-nosed catcher Ivey Wingo from the St. Louis Cardinals. Playing for Cincinnati for the rest of his career, to 1929, Wingo was a solid part of the Reds defense. His best years were 1915 through 1921. For his time in the majors, Wingo played 1231 games at catcher.

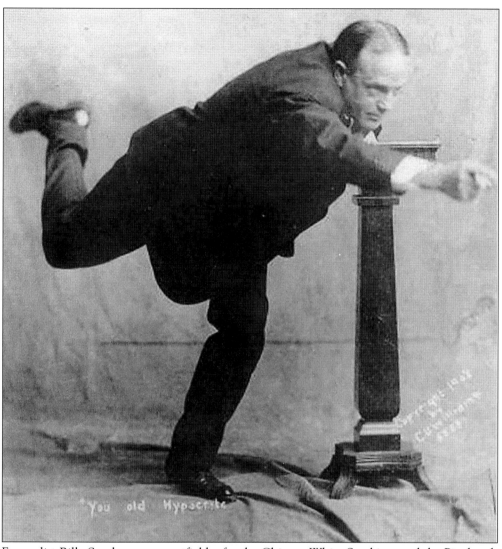

Evangelist Billy Sunday was an outfielder for the Chicago White Stockings and the Pittsburgh Pirates from 1883 to 1890, but the fleet-footed outfielder left the game when he realized his calling for the pulpit. He didn't leave the sport completely behind. Sunday was known for his flamboyant revival preaching, attracting thousands to his "tent cities" wherever he went. A large part of his attraction was his use of baseball metaphors in his sermons, and incorporating stories from his playing days. In 1915, invited to preach in Cincinnati, he called the city a "cesspool of rot and filth," but finally agreed to a revival in 1921. Often Sunday would rant and rail about the bad habits of ballplayers, particularly in the use of alcohol and tobacco, big problems in baseball during the 'teens, and Cincinnati at the time was a major producer of both. One story he told was of a former teammate, pitcher John Clarkson, who happened to have won 326 games over a 12-year career, including 53 wins for Chicago in 1885. Clarkson was elected to the Hall of Fame in 1963. Sunday said he was the "greatest of them all." But, he would go on: "Poor John died up in Massachusetts in an insane asylum. Cigarettes broke down his health. I have known him to smoke eight and ten boxes of them in a day. I used to room with John. The water would be stained with nicotine when he'd take a bath." But then, nothing was said about how often Clarkson might have bathed.

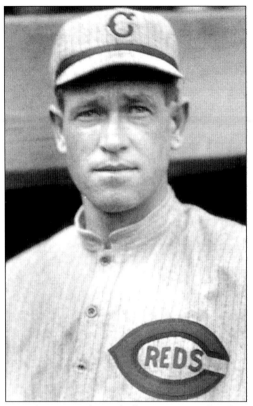

And as the gambling issue worsened in the years before the Great War, the National Commission found themselves face-to-face with some serious issues. Perhaps the most infamous gambler in baseball at the time was first baseman Hal "Prince Hal" Chase, who began his Major League career in 1905 with New York in the American League. By 1916, Chase landed with the Reds, and was with the team through the 1918 season. For a first baseman, it is fairly easy to influence the outcome of the game: pulling your foot off the bag as the throw arrives, juggling the ball as the runner crosses the base can all lead to runs and a loss. The curious thing about Chase is that for the most part he was a loner. His situation wasn't like what would happen a few years later when the White Sox players conspired to throw the World Series. Chase acted for himself. He even had a winter traveling basketball team that undoubtedly saw Chase throw games as well. Garry Herrmann had suspicions about Chase, but because his own power in baseball was eroding, he was unable to get Chase blacklisted. Finally, after spending the 1919 season with the Giants, Hal Chase was out of Organized Baseball. Despite it all, Chase is considered one of the better fielders of his generation, though his "errors" were often among the most for first basemen.

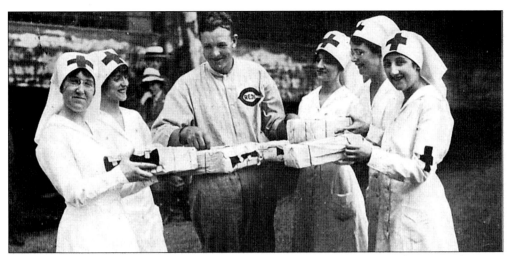

On July 20, 1916, the Cincinnati Reds made a trade with the New York Giants that sent utility man Red "Lollypop" Killefer and infielder Buck Herzog to New York in exchange for Edd Roush, Bill McKechnie, and the incomparable "Matty," the great Christy Mathewson. Mathewson replaced Herzog, who was the Reds manager. By this time, he was in the final stages of his playing career. In fact, he pitched his only game for the Reds—and the last of his career—on September 4, 1916 against another legendary hurler at the twilight of his career, Three Finger Mordecai Brown of the Cubs. Mathewson won for the 373rd time, 10-8. Always noted for his fastball and curve, when Mathewson came to Cincinnati, he experimented with a "double curve" which, according the *New York Times*, was "snake-like" and ". . . jumps two ways in the most black magic fashion…[It] takes a decided outward hop and then shoots in again." In 1918, Mathewson left the Reds to serve as an Army captain in the Chemical Warfare Division. Coupled with a bout of flu and the accidental inhaling of poison gas, his health began to fail after his return to America that fall. By 1920, he had tuberculosis and he died in 1925. Christy Mathewson represented the myth of what Americans wanted from their baseball heroes: good-looking, Christian, white, educated, polite, and the "white hat"antithesis to the likes of "black hats" such as Ty Cobb and Hal Chase. In the top photo, Mathewson is shown helping out at a Cincinnati bond rally during World War I, and in the bottom photo he is shown helping to sell Christmas seals for tuberculosis treatment a few years before his death.

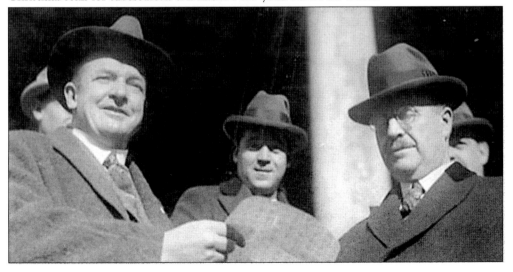

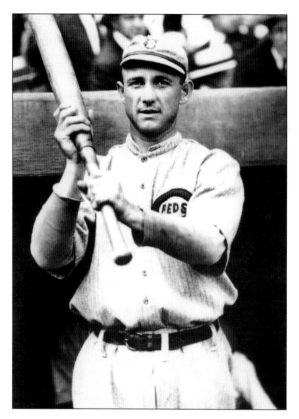

Henry "Heinie" Groh first played for the New York Giants in 1912, but came to the Reds during an early season trade in 1913. A colorful fan favorite, Groh was known for his unusual "bottle" bat that featured a narrow handle that extended to a thick, bottle-shaped barrel. Groh had excellent years with Cincinnati until he was traded back to the Giants in 1922. He formed part of the strong-fielding clutch-hitting team that went to the 1919 series. In his time with the Reds, Groh hit for a .298 average and had over 1300 hits.

Righthander Hod Eller had a relatively short career, playing in the Majors with Cincinnati from 1917 through 1921. Known for his "shine ball" in which he would rub the baseball with paraffin or another slick substance, Eller had his best year in the World Series championship season of 1919, going 20-9. The shine ball was his signature pitch, but in 1920 the rules changed. In an effort to clean up the game, trick pitches were outlawed. The change was in part to restore the game as pure in the minds of fans. The ban of the spitball and other such pitches came on the heels of a the Spanish Flu epidemic that in just 18 months killed 600,000 people in the United States and 40 million worldwide. And then it was gone. But public hygiene was a main concern, and this filtered into baseball. Along with the resolve to make the game "fair" and eliminate gambling, Rule 8.02 stated: "The pitcher shall not: apply a foreign substance of any kind to the ball or his glove, expectorate either on the ball or his glove, or deface the ball in any manner." Seventeen pitchers were grandfathered in with their trick pitches, but Eller's arm had already seen its best days.

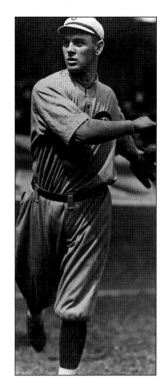

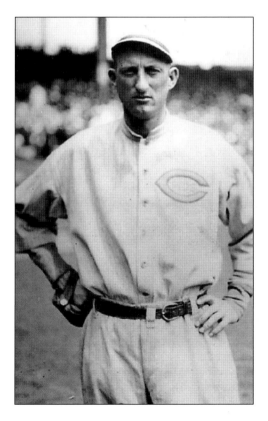

Harry "Slim" Sallee was from nearby Higginsport, Ohio and began his career with the Cardinals. Midway through the 1916 season, he was dealt to the Giants, and in yet one more of those connections on the Reds-Giants highway, he came to Cincinnati in time to begin the 1919 season. He was outstanding that year, winning 21 games against 7 defeats, and was 1-1 in the Series, with a superlative 1.35 earned run average.

Ironically after years and years of Garry Herrmann being the power in Organized Baseball and his team languishing in the standings, as his team was being built for the championship year of 1919, Herrmann's clout was fading quickly. The Reds were matched in the World Series by the redoubtable White Sox, led by pitcher Eddie Cicotte (left) and outfielder "Shoeless Joe" Jackson (below). Both players had already enjoyed considerable success in baseball. Cicotte was acknowledged as one of the best pitchers in the 'teens, and Jackson has been regarded as one of the best pure hitters ever to play the game. But approached by gamblers, both accepted the terms. Though they had beefs with Charlie Comiskey, the owner of the Sox, both were fully aware of what they were doing. Over the decades, Jackson has been portrayed as a tragic figure, his illiteracy mentioned frequently as a mitigating factor in the '19 scandal. But illiteracy is not stupidity. Jackson was an experienced ballplayer who knew what was what. And though he had an excellent series—he batted .375—he accepted payoffs.

Gangland financier Arnold Rothstein was the money behind the fix. Rothstein had worked his way up in New York organized crime with a brilliant mind for making money and organizing graft. He was the bankroll behind crooked racetracks and illegal gambling dens. After Prohibition began in 1920, Rothstein also financed bootlegging operations and the hijacking of trucks loaded with hooch. He would eventually be killed during a poker game in

1929. The bagman for delivering Rothstein's money to the players who would throw the games was a former featherweight champion boxer named Abe Attell. Attell was basically a pug who enjoyed the underworld he found in boxing, and after his ring career was over, continued to be involved in betting.

The ringleader in it all was first baseman (again the first baseman!) Charles "Chick" Gandil. He was the conduit to the gamblers and arranged the conspiracy with Cicotte, Jackson, shortstop Charles "Swede "Risberg, utility infielder Fred McMullin, pitcher Claud "Lefty" Williams, and center fielder Oscar "Happy" Felsch. Third baseman Buck Weaver completed the "eight men out" conspiracy because he knew about the payoffs, but kept it quiet. After 1919, Gandil was gone from the Majors, and reportedly ended his days playing in outlaw leagues in California, and boxing in the back rooms of saloons.

The streets around Redland Field were jam-packed for the first game of the 1919 World Series. More than 30,000 people attended that game and saw the Reds roll to a 9-1 victory over the Sox. Dutch Ruether held the American Leaguers to just six hits. In the bottom of the first inning when the Reds came to bat, White Sox ace Eddie Cicotte provided a signal to the gamblers that the fix was on when he plunked leadoff hitter Morrie Rath in the back, sending him to first base.

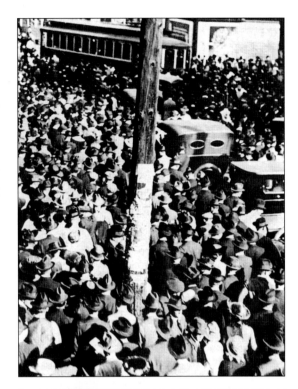

As part of the 1919 World Series festivities, the last three surviving members of the Red Stockings in 1868–1869—Cal McVey, Oak Taylor, and George Wright—were borne along in a downtown celebration. It was a half-century since the Cincinnati Red Stockings had set the baseball world on fire with their season of 57 wins and no defeats, so it was fitting that in 1919 the team found itself in the position of again being the sport's best team.

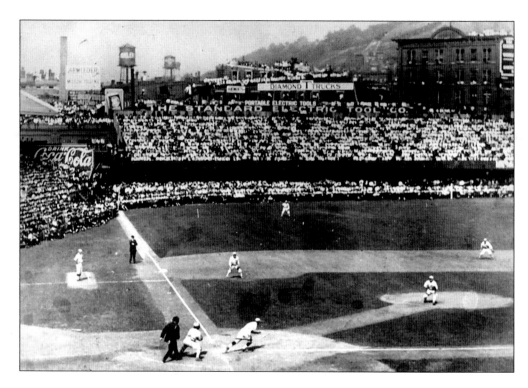

With the games underway in Cincinnati, the top picture shows the temporary bleachers erected in the outfield to accommodate the crowd. In the bottom of the first, Reds first baseman Jake Daubert has just singled off Eddie Cicotte, moving up Rath. Shoeless Joe is in left for the Sox, and Bucky Weaver is at third. In the bottom image of the second game, also in Cincinnati, Reds right fielder Earle "Greasy" Neale is thrown out at second base, as Risberg plays this one legitimately and slaps on the tag. Lefty Williams is on the mound. In the buildings beyond the center field fence and the right field bleachers, fans can be seen in the windows of the businesses around the ballpark.

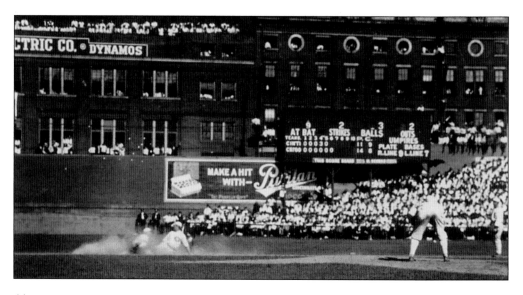

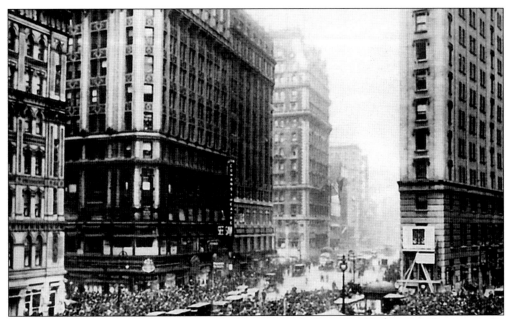

Throngs of baseball fans crowded outside the New York Times Building in Manhattan as the Series began. The Times mounted a board outside its front door so it could track the play-by-play as the action happened in Cincinnati.

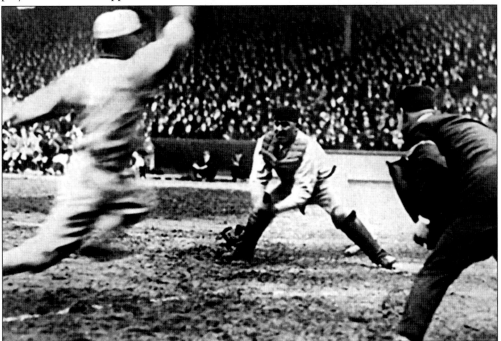

White Sox third baseman Buck Weaver begins his slide for home during the 1919 World Series as Reds catcher Ivey Wingo braces to make the tag. Weaver was the true tragic figure of the ensuing scandal. Though he knew about the payoffs, he refused any overtures to make him a part of it, and he played the Series on the level. His offense was that he knew, but didn't tell. For his silent complicity, he would be banned for life from Organized Baseball.

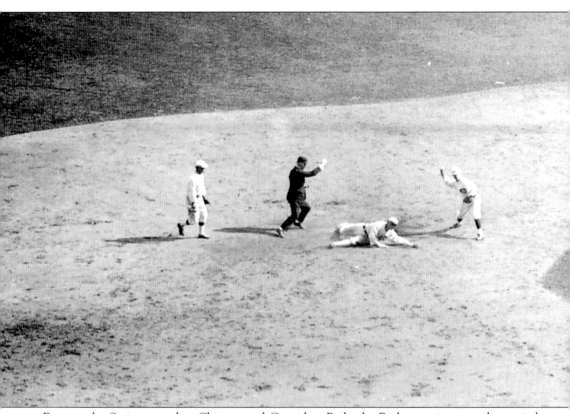

Even as the Series moved to Chicago and Comiskey Park, the Reds were in control, stymied only by the Sox's young pitcher Dickie Kerr, who won Game Three. This image shows one of the Chicago games, the Reds again making an easy put-out at second base. The Reds jumped to a 3-1 advantage after winning Game Four, a game in which Cicotte made two errors on a dropped put-out throw, and a wild throw to first. Hod Eller pitched a three-hit shutout and gave Cincinnati a 4-1 games lead in the third Chicago game. The Sox took the next two games, the October 8 contest in Cincinnati only drawing 13,923 fans. But more than 30,000 came the next day to see the Reds shell Lefty Williams and win the Series five games to three. Herrmann and the other owners had determined that the 1919 World Series would be nine games instead of the traditional seven, in part to recoup some of the losses from missed games during the final year of the war the season before. But as the Series progressed, that something was amiss was obvious. By October 15, six days after the Series conclusion, Comiskey offered a reward for information on a fix. Nearly a year later, in September 1920, the conspiracy would finally be out in the open after the efforts by Chicago sportswriter Hugh Fullerton uncovered it.

THREE

A Golden Age in Baseball
and the World of Sport
1920–1929

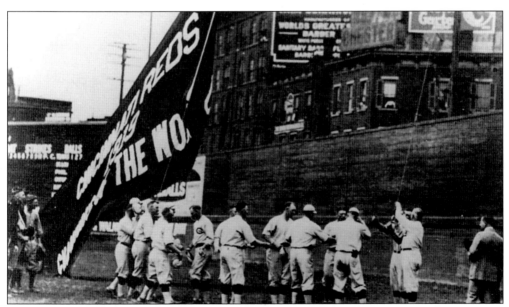

As the 1920 season began, the Reds raised their 1919 championship flag by the right field wall. Forever after, the World Series victory over the Chicago White Sox would be tainted by the gambling scandal, but the Reds were champions nevertheless and the pennant was earned by a very solid baseball team.

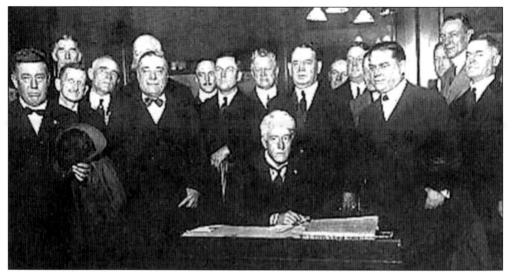

On September 28, the grand jury in Chicago indicted the eight White Sox involved in the fix. On November 20, the tripartite National Commission system came to an end, when the owners, seeking to fix the game they had let get out of hand, hired Chicago federal judge Kenesaw Mountain Landis as the sole arbiter of the sport. There had been other plans to change the way the Majors were ruled. In 1919, Albert Lasker, a shareholder in the Cubs and Chicago advertising executive, proposed a three-member National Commission made up of people outside of baseball. But the owners recognized that power needed to be wielded by one individual. The above photo shows Landis on that historic day. Herrmann can barely be seen, fifth from the right. In 1921, the White Sox conspiracy trial ended when confessions the players had signed mysteriously disappeared. It didn't matter to Landis; on August 3, he kicked the conspirators permanently out of Organized Baseball, including Buck Weaver. The bottom photo shows the White Sox at the trial. Their smiles would be short-lived. Seated from left to right are Chick Gandil, Lefty Williams, Swede Risberg, Eddie Cicotte, Buck Weaver, Joe Jackson, and their attorney Thomas Nash.

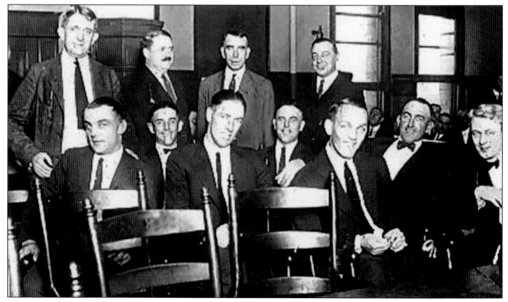

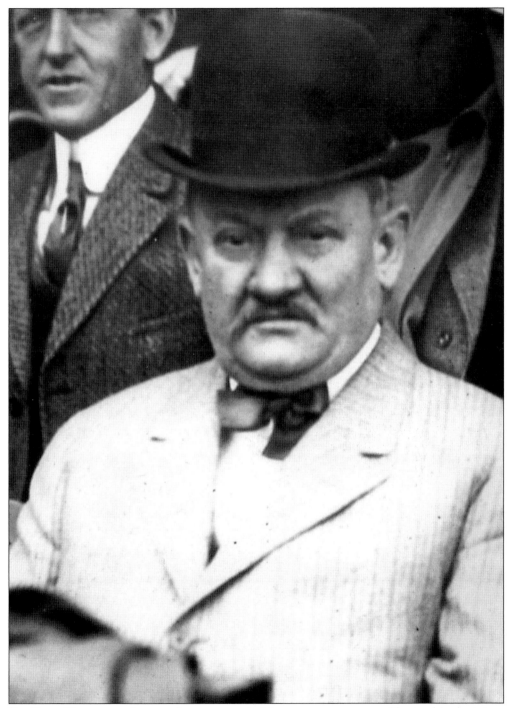

For Garry Herrmann, the proudest moment in his career came to a sudden and ignominious end. He served baseball for a quarter century and his team finally won the World Series, but everything about his achievements had a hollow ring now. No longer involved in the everyday details of contracts and mediations, he would devote his remaining years solely to the Cincinnati Reds.

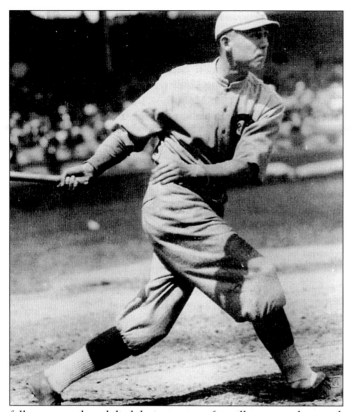

The Reds finished in third place in 1920, slipped to sixth in 1921, rose to second in 1922 and 1923, sank to fourth in 1924, finished in third and second in 1925 and 1926, respectively, but until they rebuilt the team for the late 1930s, the club would inhabit the second division. They still had outstanding players like Edd Roush (left), who contributed to a better-than-average squad with the likes of Jake Daubert, Heinie Groh, Larry Kopf, and Maurice Rath (below, left to right). But the scandal of 1919 diminished their achievement. Roush was traded to the Giants in 1927, and Daubert died at the tail end of the season in 1924. He was beaned earlier in the year, never fully recovered, and died during surgery for gallstones and appendicitis. He was 40 years old. Groh went to the Giants in 1922, infielder Kopf joined the Braves in 1922, and second baseman Morrie Rath finished his career after the 1920 season.

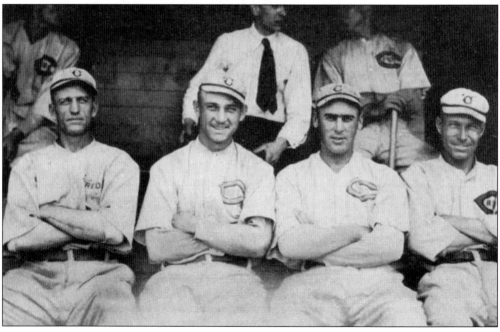

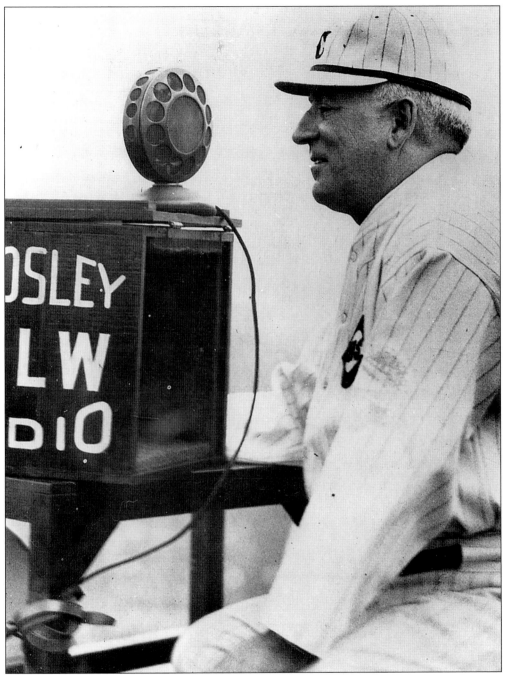

Manager Jack Hendricks piloted the Reds from 1924 through the 1929 season, keeping Cincinnati in contention, though not winning a pennant. He managed the club to 469 wins over that span, taking over the team after the sudden death of manager Pat Moran at spring training in March of '24. Hendricks is shown in this image, taking a turn behind the WLW microphone for the recent innovation of radio game broadcasts. The first airing of Reds games was on April 15, 1924 by local stations WSAI and WLW, the latter station having started baseball broadcasts in 1922 with the World Series.

Pitcher Carl Mays was traded to Cincinnati in December 1923 and played five years for the Reds. He won 20 games for the Reds his first season in '24, and 49 over his stint with the team. Mays was a submariner, throwing the ball low and under from the right. He is noted in baseball history for a tragic event when he was with the Yankees in 1920. In the dusk of a late afternoon game, his pitch swooped in on Cleveland Indians shortstop Ray Chapman, hitting him in the temple. In an age before batting helmets, Chapman was unprotected. He died from his injury the next morning. Mays had a somewhat shady reputation of not being afraid to go inside on a batter, and this, along with the suspicion that he threw an unpredictable spitter, contributed to years of debate about his culpability in the death.

Eugene "Bubbles" Hargrave was a catcher for the Reds from 1921 through 1928, before finishing his career with the Yankees. A pretty fair hitter who finished with a career batting average of .310, Bubbles (despite the nickname) was noted for his tough defensive work.

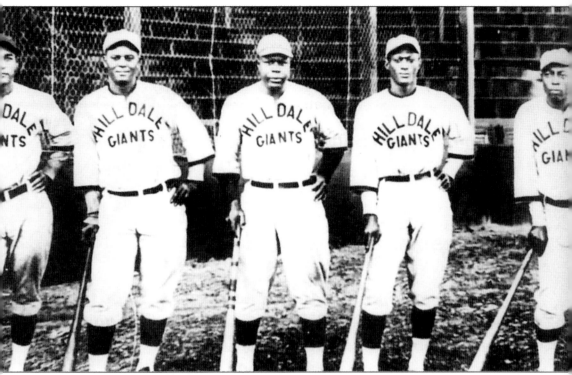

The outfield at Redland Field was so immense that the first home run hit over the fence did not occur until 1921, and, it wasn't done by a Cincinnati Red or any other National Leaguer. On May 22, John Beckwith, a shortstop for the Chicago Giants in the Negro Leagues, clouted a pitch 370 feet over the left field wall. The Giants were in town to play the Cuban Stars, the local Negro League team that leased the ballpark from the Reds to use when the Major League white team was out of town. Only 19 years old at the time, Beckwith was said to have collected a nice sum from the change that rained down on him in appreciation of his feat. He is shown here, third from left, with another team he played for, the Hilldale Giants.

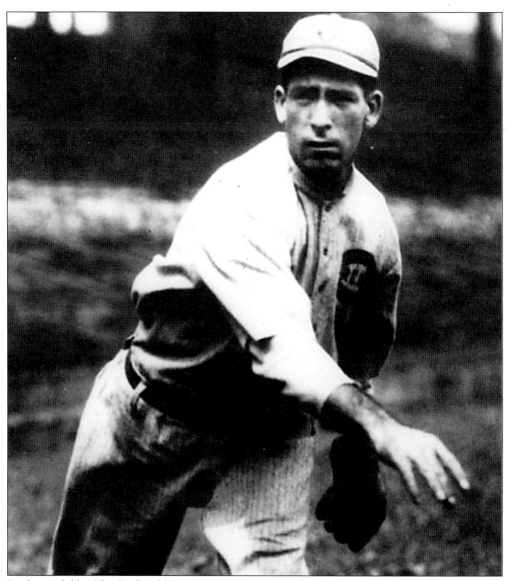

Pitcher Adolfo "The Pride of Havana" Luque came to the Reds in 1918 and had several good years with them, including an outstanding season in 1923 when he had a record of 27-8 and a phenomenal earned run average of 1.93. He pitched for the Reds for 12 years, and in that time matched his occasional brilliance on the mound with frequent displays of a temper that became legendary. In short, Dolf Luque was a head case. He was given to fights and threats, the latter accompanied at least one time with the waving of a pistol. In the winter following the 1923 season, Garry Herrmann's agent in Havana, Pepe Conte, wrote to the Reds president about his star pitcher: ". . . Adolpho has grown a head large enough to wear a number 47 hat…outside of his ability to pitch [he] is a most perfect jack-ass. He packs a "gat" and tries to make everyone believe that he is a sort of a Demi-God . . . He is a good man at heart, but a most perfect savage. I don't want you to repeat anything I am saying here because it is better not to start more trouble." Because of Luque's notoriety in America's baseball press, his long, reaching effect was that for decades, Latino players were burdened with the stereotype of being hot-headed, moody, and complaining.

Hall of Famer Eppa Rixey came to the Reds in the winter of 1921 in a trade with the Phillies that sent Jimmy Ring and Greasy Neale to Philadelphia in exchange for Rixey. Three times between 1921 and 1933, Rixey won 20 or more games for Cincinnati, and tallied 19 wins in '21 and '28. He finished his career with an overall record of 266 wins against 251 losses, but it was good enough to get him elected to the Hall in 1963. Rixey held a master's degree in chemistry from the University of Virginia. In the 1920s, for the first time, the majority of major leaguers came from rural or small town America as opposed to what had been the tradition of northeastern, urban players in the game, and more—though by no means the majority—like Rixey, had college degrees.

As early as 1869 when the Reds became an all-professional team, they trained before the regular season began as a way to get in shape for the long summer campaign ahead of them. Their first trip to a Texas site was at Fort Worth in 1898, and over the years the team alternated between Arkansas, Louisiana, Georgia, Florida, and Texas. In 1921, the Reds held spring training in Cisco, Texas, and this photo shows the team on a side trip to nearby Breckinridge to take in some of the extensive oil-drilling activity in west Texas.

The West End-Brighton neighborhood in which Redland Field was located was always a lively, working class part of town, providing not only a lifetime existence for tens of thousands of residents, but also acting as a neighborhood where Jews, Germans, African Americans, and other groups lived until rising high enough in economic status to move to the hilltops or a suburban locale.

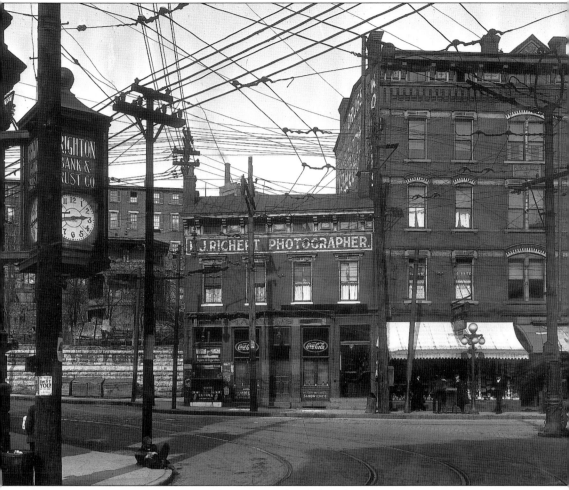

The streets and businesses around the ballpark bustled with activity—it was a border area between what sports historian Steven Riess has called the "walking city" and the "radial city"— a neighborhood where people had churches, jobs, schools, and shopping close by. In the farther stretches of the area, residents would have to take a streetcar to downtown Cincinnati and the businesses there, but recreation, including Redland Field, was within walking distance.

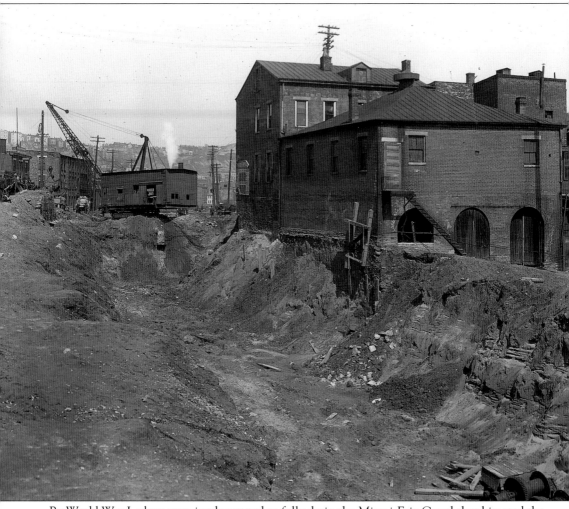

By World War I, plans were implemented to fully drain the Miami-Erie Canal that bisected the neighborhood, deepen and widen it, and build a subway system for the city. Following the war, construction began.

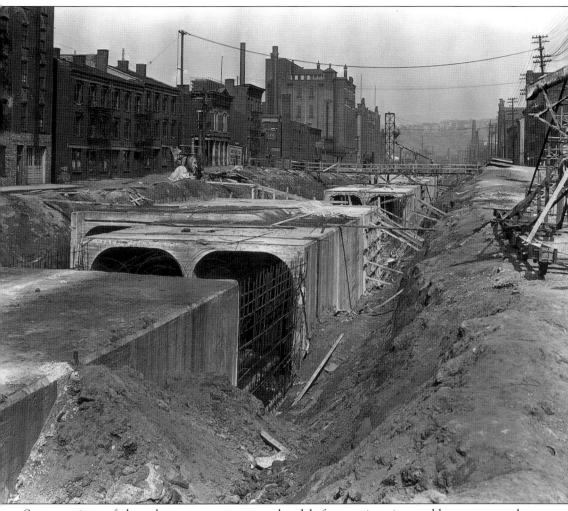

Some sections of the subway were even completed before engineering problems, structural damage to neighboring buildings, cost overruns, and that old bugaboo, political misdeeds, put a halt to the project in 1926. Later the "tunnel" was filled in and Central Parkway constructed atop it. For the Reds, the promise of thousands of fans arriving for games by subway turned to the old standby of above-ground streetcars—at least until the automobile made a permanently strong presence in the 1940s.

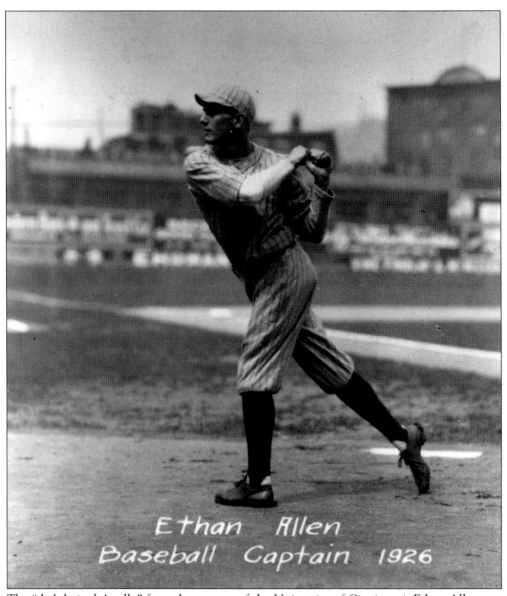

Ethan Allen
Baseball Captain 1926

The "dark-haired Apollo" from the campus of the University of Cincinnati, Ethan Allen was a superlative athlete who excelled in track and basketball as much as he did in baseball. He captained the UC Bearcats team in 1926, shown here in a collegiate game at Redland Field, and often wore his track uniform underneath his baseball flannels so he could hustle from one sport to another when events happened on the same day. Allen left UC in '26 to sign with the Reds, and enjoyed a 13-year career with a batting average of .300. He once commented that in his contract negotiations with Reds president Garry Herrmann that the hard-nosed front office man presented him with a take it–or–leave it contract, and that since he went straight to the major league roster, his game was expected to be at that level—no instruction or direction from the manager and coaches. After his playing career was finished with stints on the Giants, Cardinals, Phillies, and Browns, Allen made publicity films for the National League, coached a future president—George Bush—at Yale, and invented a baseball board game that remained popular for decades.

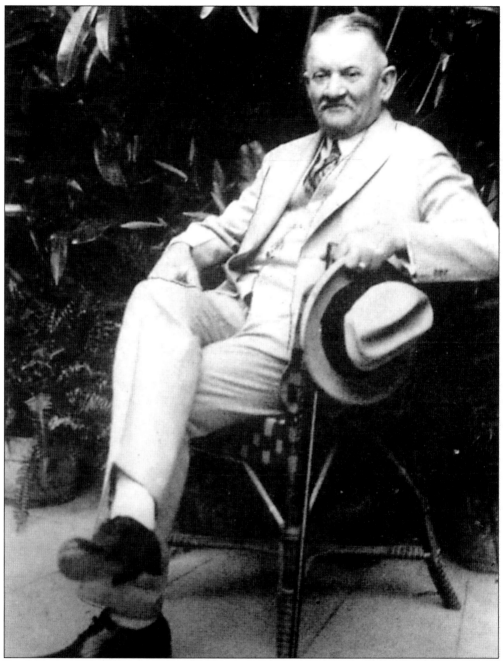

By the mid-1920s, Herrmann's health was seriously deteriorating. Though he held on to his presidency of the Reds, decades of rich food and high living took their toll. He suffered variously from diabetes and failing eyesight, arteriosclerosis, and heart problems. Though he was around to sign Allen in 1926, and to apply for a professional football franchise in Cincinnati through the American Professional Football League (the application was denied), Herrmann's sporting days were coming to an end. In 1927, he resigned his position with the Reds and went into a quiet retirement.

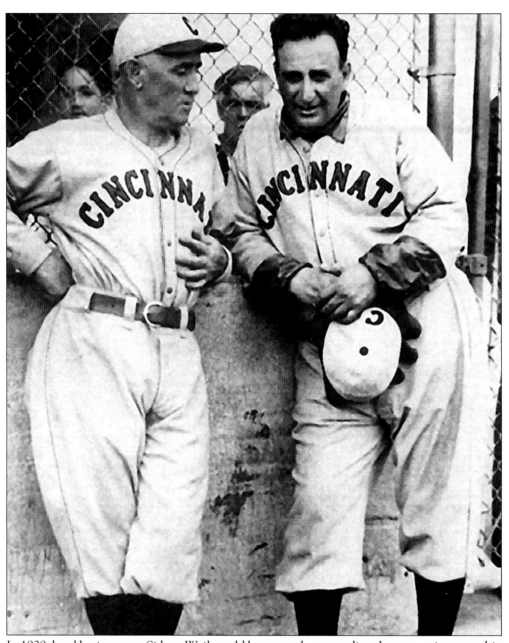

In 1929, local businessman Sidney Weil would buy enough outstanding shares to gain ownership control of the Reds. Weil built a fortune as an automobile dealer, and was a lifelong fan of the team. As soon as he became the owner of the team, Weil brought a business-like sense of order to the front office, a discipline that had fallen away after Herrmann left the club. However, Weil's ownership was to be relatively short-lived. He had invested heavily in the stock market, often buying on margin, and with the '29 Crash and the onset of the Great Depression, he found himself cash-poor. He declared bankruptcy in 1933, and the team was sold to Powel Crosley. To the end of his life, however, Sidney Weil never lost his passion for the Reds. In this photo, he is shown with team manager Donie Bush early in 1933, apparently enjoying the authority he held to wear his own Reds uniform.

FOUR

The Great Depression and a World Series
1930–1939

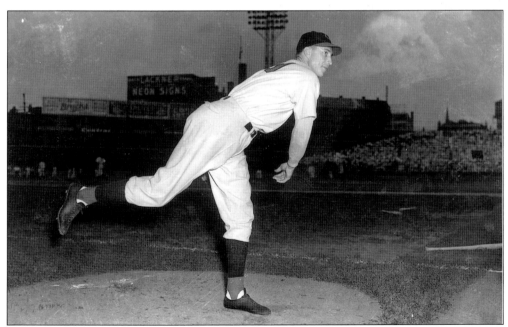

Bucky Walters was an exceptionally accomplished pitcher for the Reds at the end of the 1930s and into the 1940s. Though he lost two games in the '39 series against the New York Yankees, he came back the next year to win two against the Detroit Tigers to help the Reds nail down their second World Championship. (Photo by Eugene Smith, courtesy of the University of Cincinnati.)

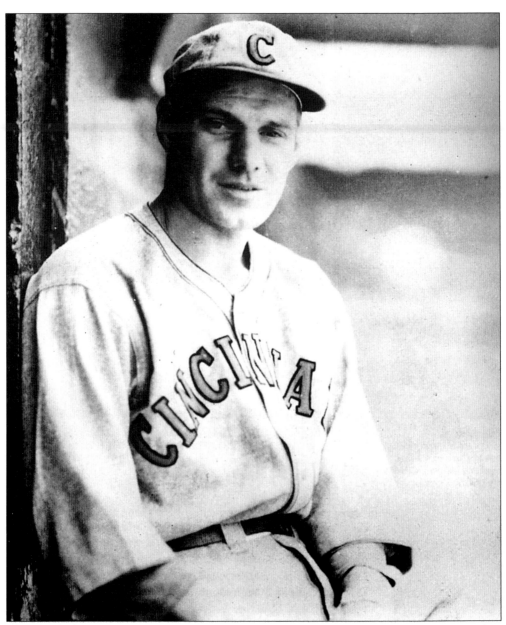

Leo "The Lip" Durocher was traded to the Reds from the Yankees in February of 1930. Durocher wore out his welcome with the Yankees, particularly with Babe Ruth. At various times he was suspected of stealing from his teammates, and his penchant for fine clothes and fast women often landed him in debt. Even after he came to the Reds, Durocher had to be bailed out by Reds owner Sidney Weil. But he was an excellent fielder, if somewhat inept with the bat. He earned the "Lip" nickname for his belligerent arguing on the field, and it would continue after he became one of the outstanding managers of the game, particularly with the Dodgers and the Giants. As it was, by 1933 he was gone from the Reds, shipped off to the Cardinals, where he became a member of the famous "Gas House Gang" of the St. Louis team. The trade worked out well for the Reds: one of the players they received in exchange in the trade was Paul Derringer, who became one of their great hurlers.

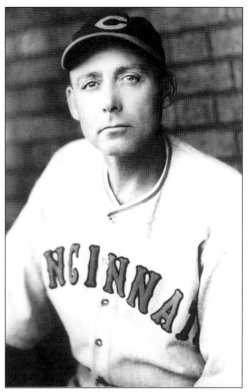

In 1931, Edd Roush returned to the Reds
after playing three years with the New York
Giants. Roush sat out the 1930 season in
a contract dispute—not a surprise for a
player who regularly had disagreements with
management over what he was worth. And
all things considered, he was an excellent
judge of his own talents. In March, a local
newspaper cartoonist welcomed Roush,
noting that the Reds had amounted to little
in the years after he was traded in 1926. For
the '31 season—his last—Roush hit just .271,
but he finished with a career average of .323
over 18 seasons, and in 1962 he was elected
to the Hall of Fame.

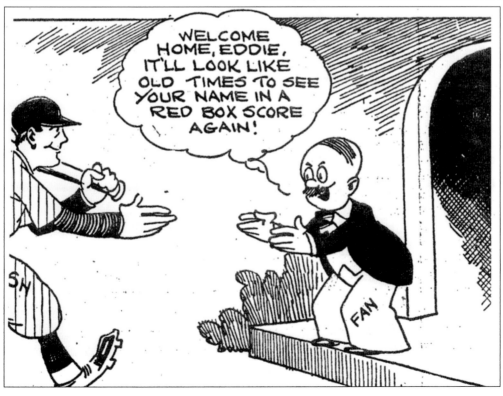

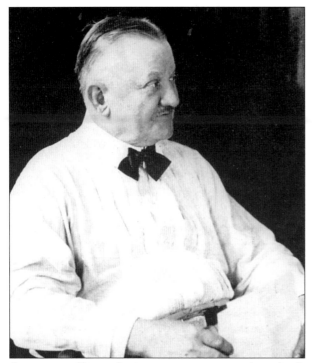

On April 25, 1931, Garry Herrmann died. He was 71 and newspapers virtually everywhere across America carried an obituary. Though he was not always the most well heeled owner—for most of his tenure, the Reds were only a marginally profitable operation—he was arguably the most important sportsman in the first quarter of the century. His mediation among owners and syndicalism of clubs, his experimentation with night baseball, his stewardship of the World Series, his forays into German *turnfest*, football, and horse racing, made him a national figure well above the reputation he earned through his Republican politics. On April 29, Herrmann's funeral was held in Cincinnati's Elks Temple, attended by hundreds of Cincinnatians and notables from the baseball and political worlds. He was buried in the German Evangelical Protestant, or Vine Street Hill, Cemetery, a fitting place for a man who was quintessentially a Cincinnati German. And as the next several years unfolded, the newspaper reporters and raconteurs who had known Herrmann told and retold the stories of his huge appetites for food and drink, his flouting of Prohibition laws, his handling of players and other owners, until they became the stuff of fond legend.

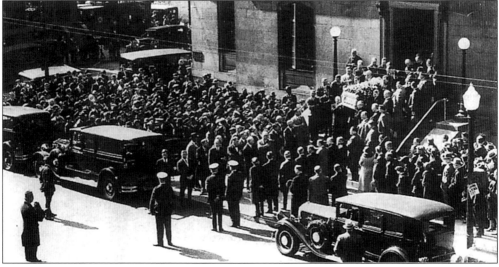

Just two years before Herrmann, death claimed another legendary Cincinnati baseball man. Miller Huggins, at the peak of his managerial career with the New York Yankees, died of erysipelas, a strep infection known as "St. Anthony's Fire." Only 49 at the time of his death in New York on September 25, 1929, Huggins had finished his player-manager career with the St. Louis Cardinals in 1916 and served solely as manager in 1917. In 1918 he became the manager of the Yankees and led them to pennants in '21, '22, '23, '26, '27, and '28, with World Series championships in 1923, 1927, and 1928. His 1927 team is considered one of the great ones of all time—the Yanks of Babe Ruth, Lou Gehrig, Herb Pennock, Waite Hoyt, and Bob Meusel. Huggins was brought back to Cincinnati for burial in Spring Grove Cemetery, and his funeral attracted people throughout baseball, including New York Giants manager John McGraw (shown wearing the hat in the bottom photograph).

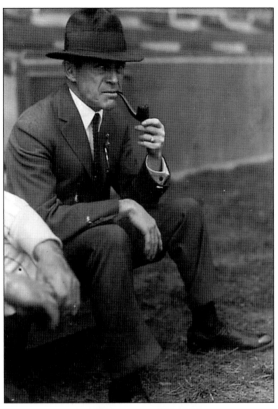

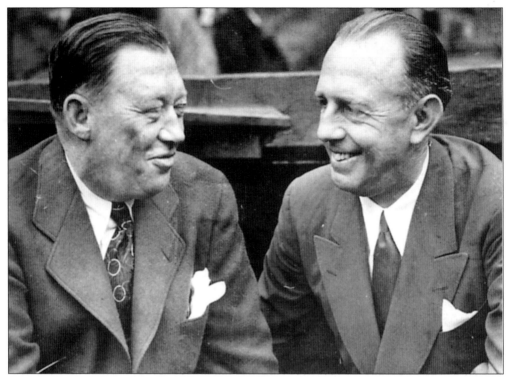

After Sidney Weil was forced to give up the Reds because of his increasing financial problems following the stock market collapse in 1929, he was replaced by Larry MacPhail, who had headed the Columbus minor league team in the American Association. MacPhail was hired by

The Central Trust Company of Cincinnati, which had acquired Weil's ownership shares. MacPhail was the perfect man for the job. Always looking to promote the team, he saw the future of radio, of night baseball, and marketing as vital elements to baseball. In 1934, Powel Crosley purchase the team from Central Trust. An inventor and self-made millionaire, Crosley recognized the talent of MacPhail for running the club. Shown together in the top image (MacPhail at the left, Crolsey at the right), the two made a good team. In April, Redland Field was renamed Crosley Field, and Red Barber (left) was hired to broadcast the games on radio. MacPhail would move on to New York, first to the Dodgers and then to the Yankees. Barber would head east as well in 1939, and became one of the best baseball broadcasters in the game.

In 1935, nearly a quarter century after Garry Herrmann had seriously considered introducing night baseball to Cincinnati, the time was right for another try at playing under the lights. Under the leadership of the innovative Crosley and MacPhail, light towers were designed for Crosley Field, and a new experiment was under way.

In 1984, a man by the name of Robert Payne walked into the Archives at the University of Cincinnati. A military chaplain in Colorado by occupation, Payne was visiting Cincinnati and had some photos with him that he wanted to share. What he had was a treasure trove of a signature event in baseball history. Payne's late father, Earl Payne, had been an engineer with the Cincinnati Gas & Electric Company. A graduate of UC's College of Engineering, the elder Payne had used his co-op education experience to land a job with C.G. & E. as a lighting specialist. It was he who designed the lights for Crosley Field that would usher in night baseball in the Major Leagues. On May 24, 1935, the Reds hosted the Philadelphia Phillies for that first night game. Earl Payne was on hand to see his that his lights operated properly, and he brought along a camera to capture the events of the evening. As President Franklin Roosevelt sent a telegraph signal to the ballpark, Larry MacPhail stood behind a table set on the field and hit the switch. The ballpark came to bright life as the fans in the seats waited for the game to begin.

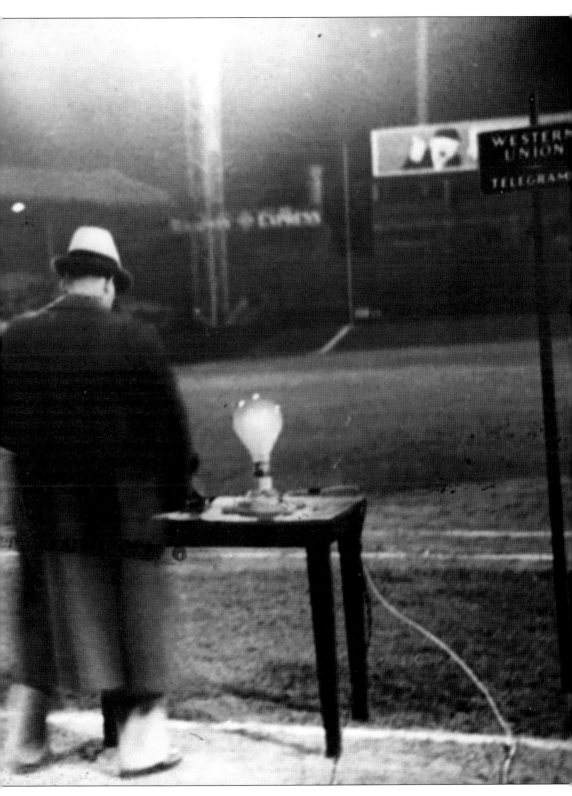

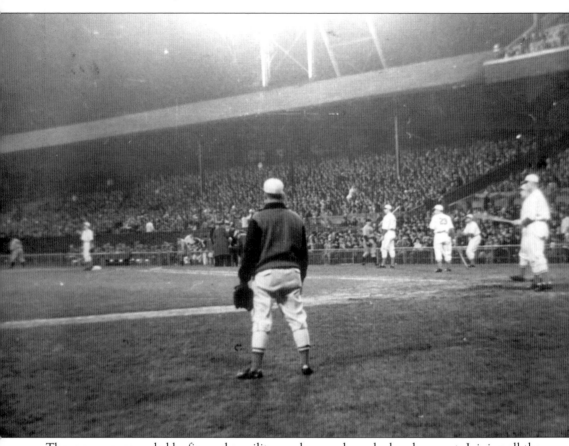

The game was preceded by fireworks, military color guards, and a band concert. Joining all the city dignitaries and National League president Ford Frick was a Mr. George Cahill, the man who had joined with Garry Herrmann back in 1909 to try night baseball. Interestingly enough, the Reds had also played the Phillies that day as well, though they were slated to play a local

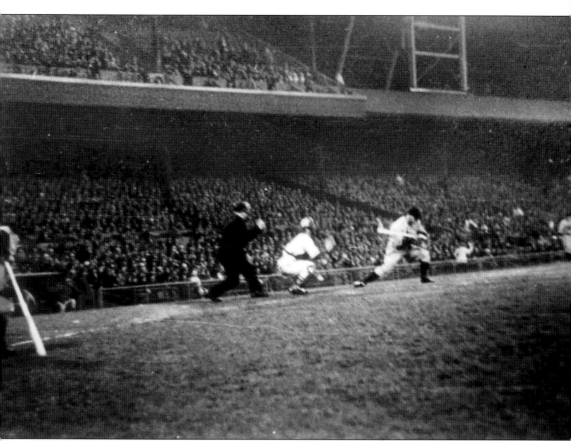

Elks team for the night game following their contest against the Phils. Herrmann pulled the Reds out of that one, but this time it was for real. Playing in front of a crowd of 20,422 fans, the Reds beat the Phillies 2-1, with Paul Derringer getting the win.

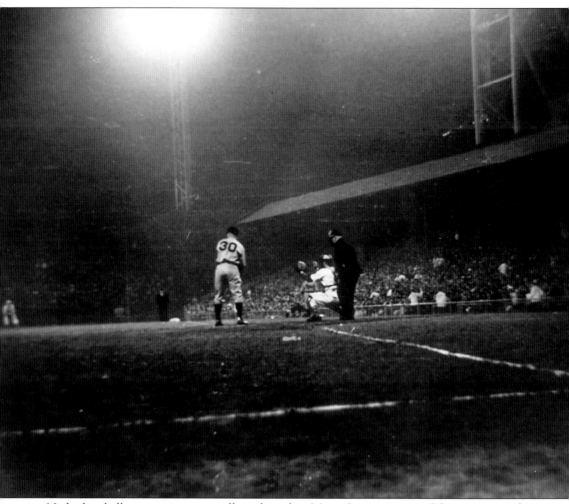

Night baseball was not an easy sell to the other Major League teams. Of course, something had to be done to boost attendance when it fell off during the Great Depression. The Reds were a mediocre-to-bad team that certainly wasn't drawing fans by great performances. In 1932, they finished in eighth place, last again in 1933, and last in 1934. Twenty-five per cent of the nation's work force was laid off by 1933, when the economy hit rock bottom. Baseball's attendance was 6.3 million and nearly all the franchises were losing money. Salaries were cut

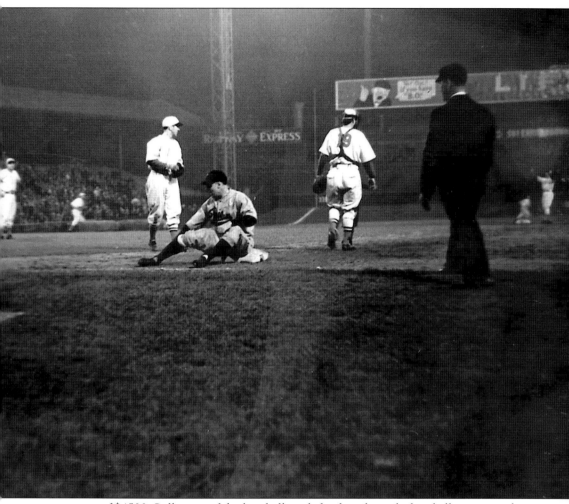

to an average of $4500. Still, most of the baseball poobahs thought night baseball was a novelty and nothing more. The Reds proved otherwise. The previous winter, the National League had granted permission for each club to stage seven night games. For the Reds, the result was an increase in attendance, averaging over 18,000 fans for each of those seven games, and almost 5,000 for the 69 day games they played. Perhaps it also stimulated better play—they moved from last place to a sixth place finish in 1935.

A marvelous pitching tandem for the Reds, Paul Derringer (left) and Johnny Vander Meer (below) were two of the key factors in leading the team to competitiveness in the late '30s. Derringer (or "Oom Paul") won 20 or more games per season in '35, '38, '39, and '40. While Vander Meer did not match those figures, his quality was consistency. He could be counted on for 15 to 18 victories a year for most of the decade. Vander Meer's lasting legacy in baseball history, however, is his back-to-back no-hitters in 1938. On June 11, he fired the first one, a victory against the Boston Braves at home in Crosley Field. He only struck out three batters, but accomplished the first no-hitter since Hod Eller threw one in 1919. Four days later, for his next start, Vander Meer and the Reds were in New York to play the Dodgers, ushering in the age of night games for Brooklyn. Tossing his second no-hitter, Vandy and the Reds beat the Dodgers 6-0. Again, the game wasn't a sterling effort on Vander Meer's part: he walked eight batters, but managed to make the Dodgers hit infield balls for most of the night.

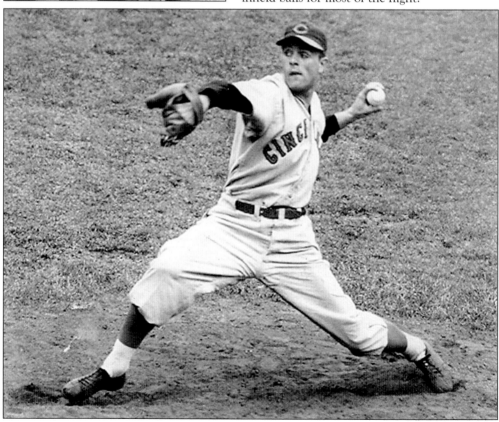

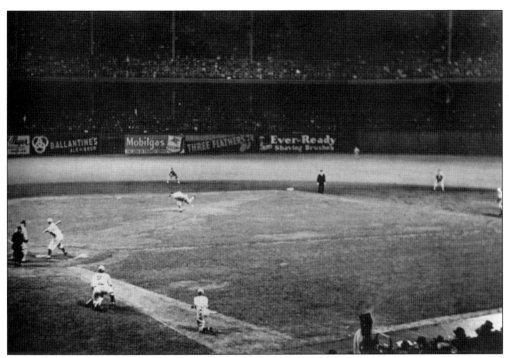

The top photo shows Vander Meer pitching the Brooklyn game. The bottom image is of him in the off season at his home in New Jersey, holding the baseballs that finished the games. For the greatness of his accomplishment (no pitcher has ever duplicated the feat), that winter Vander Meer was augmenting his baseball salary by selling cars for a Paterson, New Jersey auto dealer.

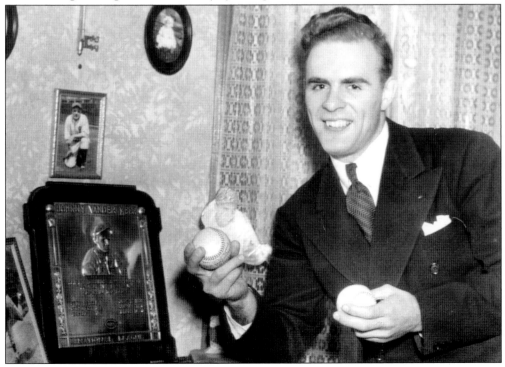

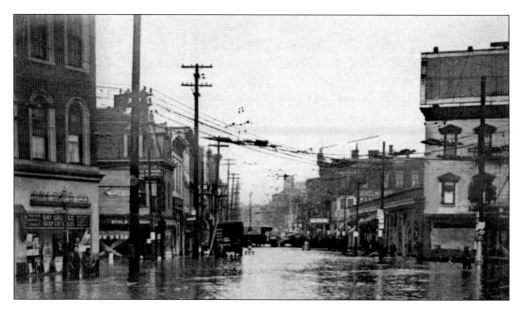

With what happened the previous year, Vander Meer and the Reds were probably lucky there was even a Crosley Field to play in. The worst flood in Cincinnati history struck the city in late January of 1937. With rain and melting snow, the Ohio River flooded to a crest of 79.9 feet. Water backed up the Mill Creek, which ran near the ballpark, covering the field with 21 feet of water. The Cumminsville neighborhood and home to one of Powel Crosley's factories, north of the ballpark, is shown in the photo above. Below is an aerial photo that shows Crosley Field and the surrounding West End neighborhood covered in water, from the railyard to the homes and businesses.

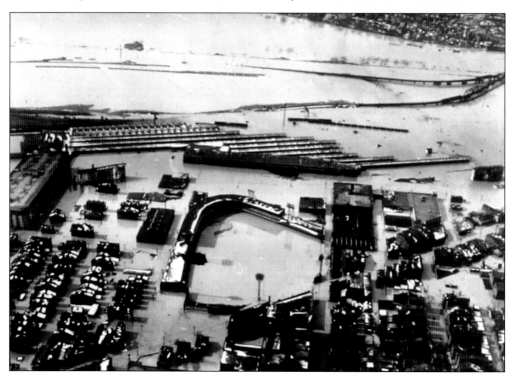

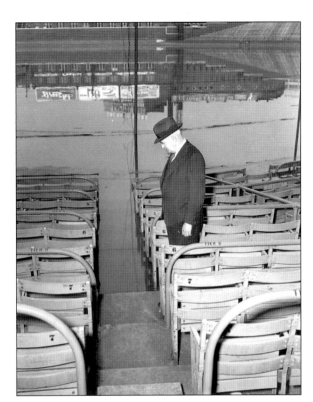

Groundskeeper Matty Schwab looks at the high water in the stands (right), and one of his groundskeepers does a little seining for fish (below). (Both photos by Eugene Smith, courtesy of the University of Cincinnati.)

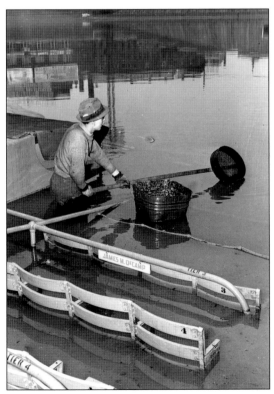

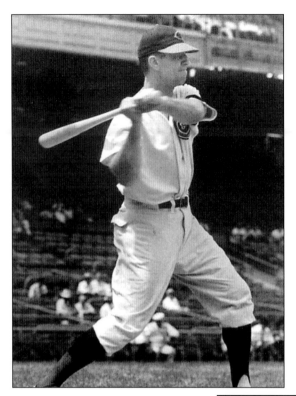

Third baseman Bill Werber played for the Reds from 1939 to 1941, playing on both World Series teams in '39 and '40. In the first one, against the Yankees, he only batted .250, but the following year his bat came to life against the Tigers as he hit .370 with ten hits.

Catcher Clyde Manion played for the Reds from '32 to '34, unfortunately when they were in the depths of the National League, and before Larry MacPhail and Powel Crosley's night games had begun. He played 13 years in the majors, mainly for the Tigers, and finished his career with the Reds.

Larry Benton pitched for the Reds the same time as Manion played, and was an example of the mediocrity of the team at the time. His best season with Cincinnati was 1933 when he was 10-11 with a 3.71 earned run average.

Joseph (Jo-Jo) Morrissey was of the same class of "early '30s" for Cincinnati. He was a utility fielder who played shortstop, third base, and the outfield.

Don Brennan mainly found himself used as a relief pitcher for the Reds in the mid-'30s, actually having a fairly good record for the time in 1936 when he was 5–2 with nine saves.

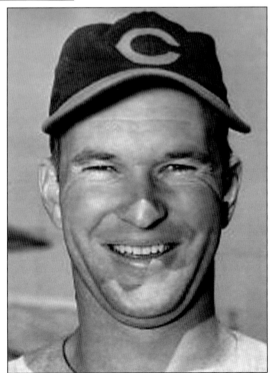

Harry Craft, however, was a legitimate star for the Reds in the late 1930s. A strong-fielding outfielder, he played in the big leagues from 1937 to 1942, all with Cincinnati.

Eddie Miller played shortstop for the Reds, his first team in the majors, from 1936 to 1937, before being traded to the Boston Braves. However, he was back in Cincinnati from 1943 to 1947 before ending his career with the Phillies and the Cardinals. He was a fairly weak hitter, but a strong glove man up the middle.

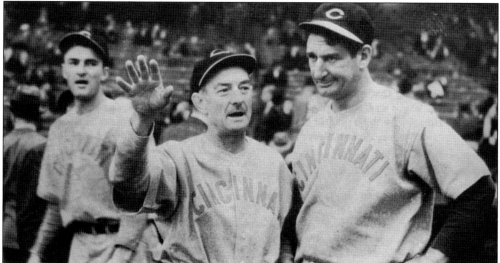

One of the best trades Sidney Weil made in his few short years as owner of the Reds was when he acquired catcher Ernie Lombardi from the Brooklyn Dodgers in 1932. For ten years, Lombardi anchored the Reds behind the plate and was one of the most powerful hitters in the National League, albeit one of the slowest. It was said that he had to hit the ball against the outfield wall in order to guarantee himself a single. No matter. His ferocious hitting and his solid defense helped lead the Reds to the World Series in '39 and '40. In this image, he is shown with manager Bill McKechnie, who took over the Reds in '38.

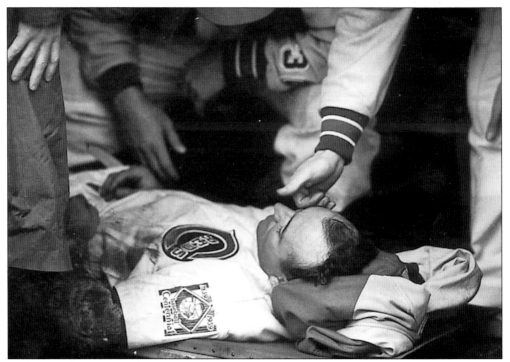

On opening day in the 1939 season, shortstop Billy Myers was beaned in a trip to the plate. Lying unconscious on the ground, Myers was carried away on a stretcher, but fortunately for the Reds he was able to recover and be a key part of the pennant-winning team. His sleeve shows Organized Baseball's centennial patch in 1939.

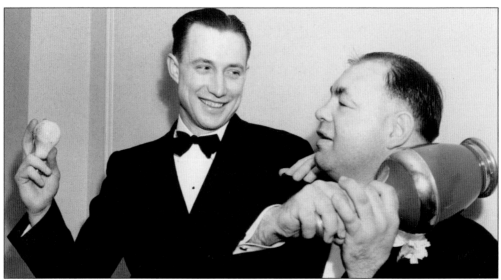

In 1939, pitcher Bucky Walters won the National League's Most Valuable Player award with a season that saw him win 27 games against 11 defeats. He was the NL leader with a 2.29 earned run average, 31 complete games, and 137 strikeouts. In this photo he is shown the night he received the MVP award, clowning with Tony "Two-Ton" Galento, a tomato can of a heavyweight boxer who was known for his training regimen of stogies and spaghetti.

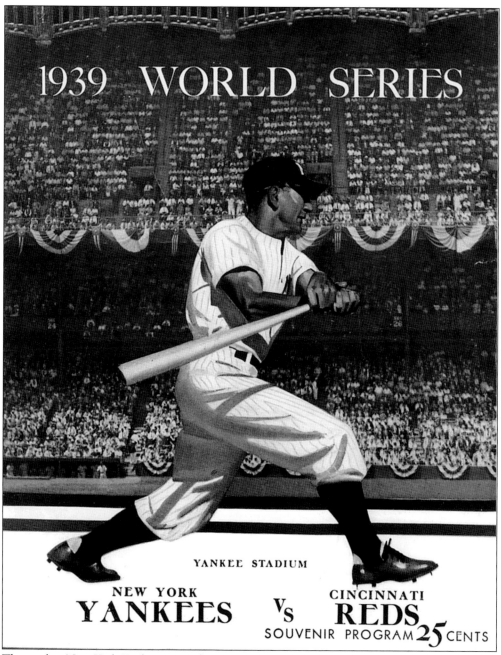

1939 WORLD SERIES

YANKEE STADIUM

NEW YORK
YANKEES vs CINCINNATI
REDS
SOUVENIR PROGRAM 25 CENTS

The mighty New York Yankees were the foes the Reds faced in the 1939 World Series. Battling for their fourth consecutive world championship under manager Joe McCarthy, the Yanks won 106 games during the regular season, against only 45 defeats. The first game of the Series was played in Yankee Stadium and the New Yorkers won by a score of 2–1, the winning run singled in by Yank catcher Bill Dickey in the bottom of the ninth.

The Yankees also won Game 2 in New York by a score of 4–0. The loss must have made Reds skipper Bill McKechnie want to turn back time to the glad hands and celebration that followed the Reds clinching the pennant on September 28, a week earlier. (Photo by Eugene Smith, courtesy of the University of Cincinnati.)

However, Game 3 was slated for Crosley Field, and the fans lined up to buy tickets. More than 32,000 people saw that game, but were again disappointed when the Yankees prevailed 7–3 on the strength of two home runs by Charlie "King Kong" Keller, Joltin" Joe DiMaggio, and Bill Dickey. (Photo by Eugene Smith, courtesy of the University of Cincinnati.)

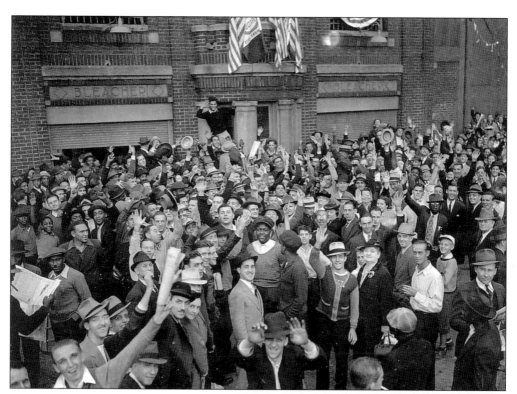

Hope did spring eternal, however, even when the hometown team hadn't been in the World Series for two decades. Fans continued to cheer on the Reds, but at three games down, the chances for a comeback were slim. (Photo by Eugene Smith, courtesy of the University of Cincinnati.)

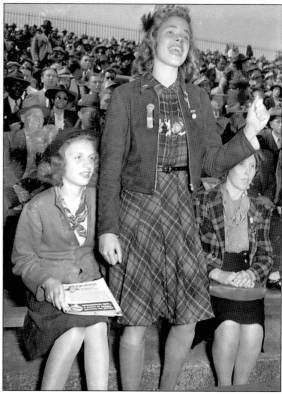

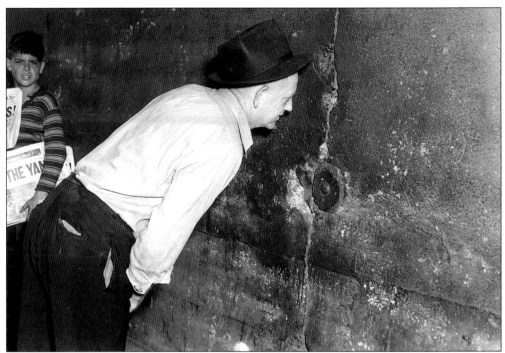

A couple of close-up peeks: one fan tries to peer through a gap in the cracked concrete wall of the ballpark as a newsboy hawks his papers with the front-page story on the powerful Yankees. In the bottom photo, a young woman gets irascible baseball czar Kenesaw Landis to reward her with a very rare smile as she snaps his picture. (Photo by Eugene Smith, courtesy of the University of Cincinnati.)

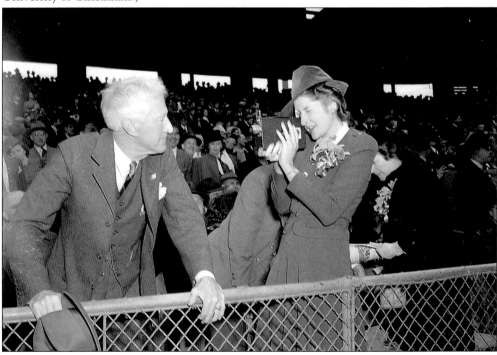

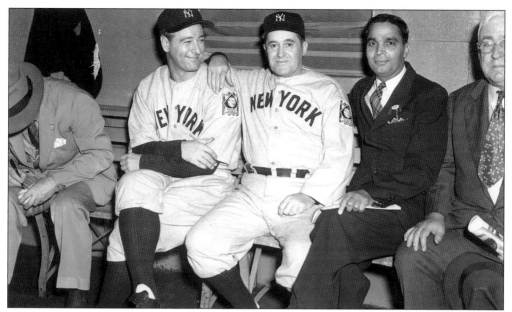

Lou Gehrig, the Yankees' "Iron Horse," would put on his uniform for the last time in the 1939 series. Stricken with amyotrophic lateral sclerosis, Gehrig had retired the previous spring, his consecutive-game playing streak set at 2,130 games. Another American Leaguer, Baltimore Oriole shortstop Cal Ripken, would break that record in 1995, but few players hold the place that Gehrig does in the American sports psyche. He became the epitome of courage and grace in the face of the devastating disease that would bear his name as its common identification. Gehrig traveled to Cincinnati for the third and fourth games of the Series, and sat in the Yankee dugout. That same year he was elected to the Baseball Hall of Fame. And, on June 2, 1941, Lou Gehrig died. (Photo by Eugene Smith, courtesy of the University of Cincinnati.)

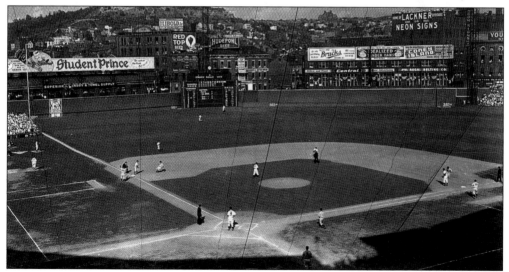

Game 4 of the series, on October 9, did not seem like the final contest for the Reds for the '39 season. Well, at least by the ninth inning. Leading 4-2 in the top of the inning, Cincinnati let the lead slip away, as Joe DiMaggio slid safely into third (shown in this photograph), and then came home to tie the game. (Photo by Eugene Smith, courtesy of the University of Cincinnati.)

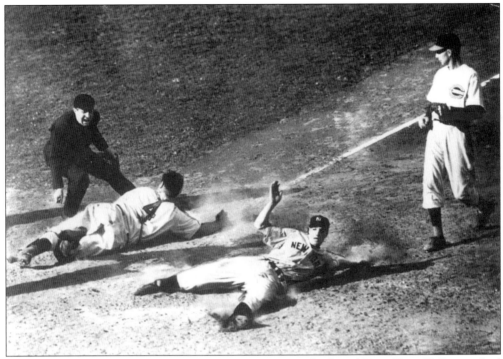

In the tenth frame, Yankee shortstop Frankie Crosetti walked, and King Kong Keller reached first on an error by Billy Myers, the Reds shortstop. DiMaggio was up next, singling to right field and Crosetti scored, starting one of the most famous plays in World Series history. In right field, outfielder Ival Goodman bobbled DiMaggio's hit, and Keller bulled around third and headed for home. He collided with Ernie Lombardi at the plate, hitting him in the groin and sending the Reds catcher off to the side. As the immobilized Lombardi lay there helplessly, DiMaggio also came in to score. The Yankees won 7–4.

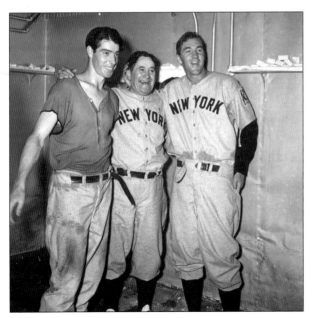

In the visitors' locker room, the jubilant Yankees celebrated their fourth World Series title in a row. Flanked by Joe DiMaggio on his right and pitcher Johnny Murphy on his left, manager Joe McCarthy reveled in his team's victory and the solid presence of a baseball dynasty. (Photo by Eugene Smith, courtesy of the University of Cincinnati.)

FIVE

A World War and a Series Championship
1940–1950

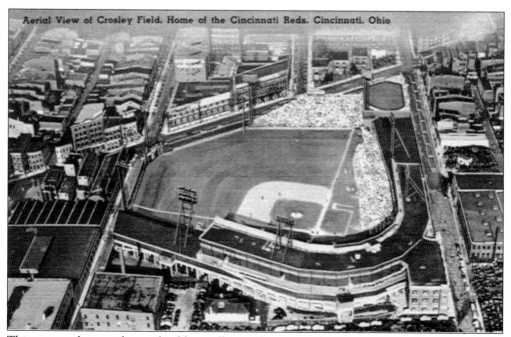

Aerial View of Crosley Field, Home of the Cincinnati Reds, Cincinnati, Ohio

This postcard view shows the blue collar rowhouse neighborhood of Crosley Field in the 1940s. It was a red brick environment, home to not only the ballpark, but to factories, homes, churches, saloons, and stores.

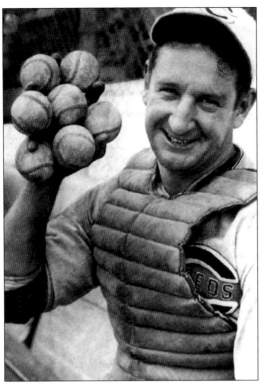

Catcher Ernie Lombardi was one of the most popular players on the team, and especially popular with ladies who often thronged around him when he moved about in public or dined in local restaurants. His massive hands attracted as much attention as his legendary schnoz. In the top photo, Lom holds seven baseballs in one hand, a publicity shot that would be taken 30 years later with another great Reds catcher, Johnny Bench. In the bottom photo, Lombardi does a similar shot for an advertisement, holding seven packs of Chesterfield cigarettes. By the 1940s, baseball players had been advertising cigarettes for more than half a century. World War I and the collection of cigarettes for the doughboys overseas had moved cigarette smoking into mainstream American life. With sports heroes promoting cigarettes, and another patriotic drive to supply the troops again in World War II, smoking continued to be popular in ads that would not begin to disappear for another quarter century.

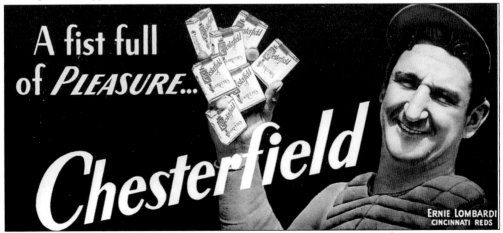

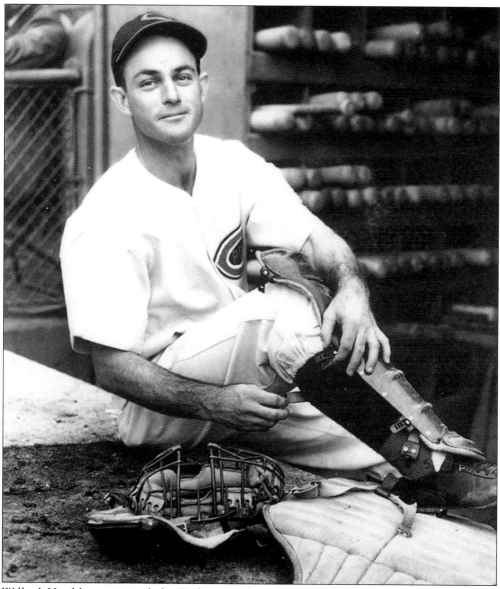

Willard Hershberger joined the Reds in 1938 and served as the backup catcher to Ernie Lombardi. He was a good hitter, popular with the fans, and a valuable asset to the team, averaging appearances in 56 games each year in '38 and '39. But Hershberger suffered from depression. His father had committed suicide with a shotgun blast when Hershberger was in high school, and he was the one who discovered the body. He became increasingly withdrawn and depressed, but still excelled enough at sports to sign with the Yankees a couple of years after high school. After several years in the minors, Hershberger was traded to the Reds. As the '40 season wore on, Hershberger lost a great deal of weight and became jumpy and nervous. When the Reds went to Boston to play the Braves, Hershberger began to feel worse. On the night of August 2, he poured out his heart to manager McKechnie, and asked if he could remain at the hotel during the next day's doubleheader. While the Reds played their game, Willard Hershberger went into the bathroom in his hotel room and slit his throat with a razor. It was a tragic ending to a sadly troubled life.

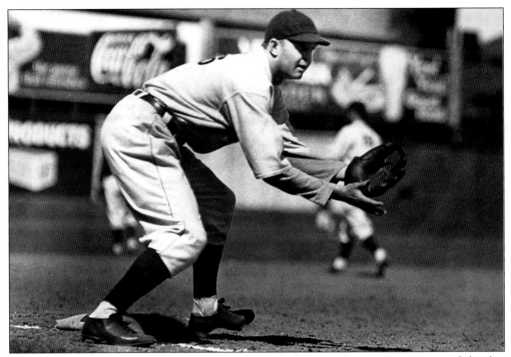

Third baseman Lew Riggs, who played for the Reds from 1935 to 1940, was one of the few players that Hershberger talked to at any length about his problems. On at least one occasion, he told Riggs that he was considering suicide.

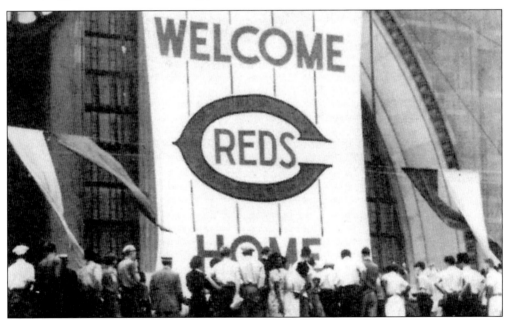

The Reds forced themselves to pull together after Hershberger's death, and continued the season as best as they could. They opened a large lead over the second-place Dodgers and ended the season winning the pennant by 12 games. In this image, loyal fans welcome the Reds back to Union Terminal after a road trip to St. Louis in late September.

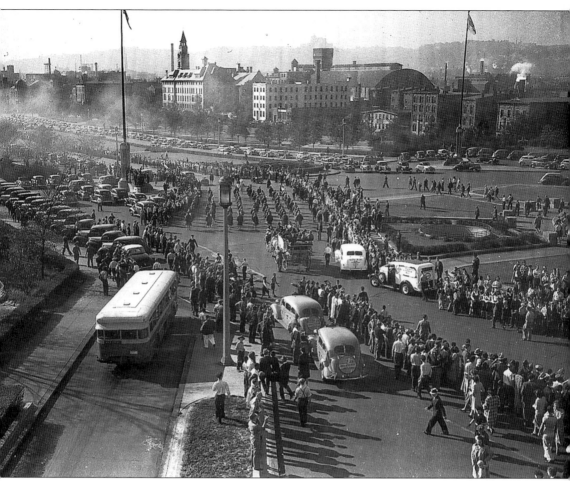

The celebration of the Reds' success heightened when the season ended with an 11–3 victory over the Pirates. It was their 100th victory of the year. As they prepared for the World Series, the crowds continued to throng Union Terminal. (Photo by Eugene Smith, courtesy of the University of Cincinnati.)

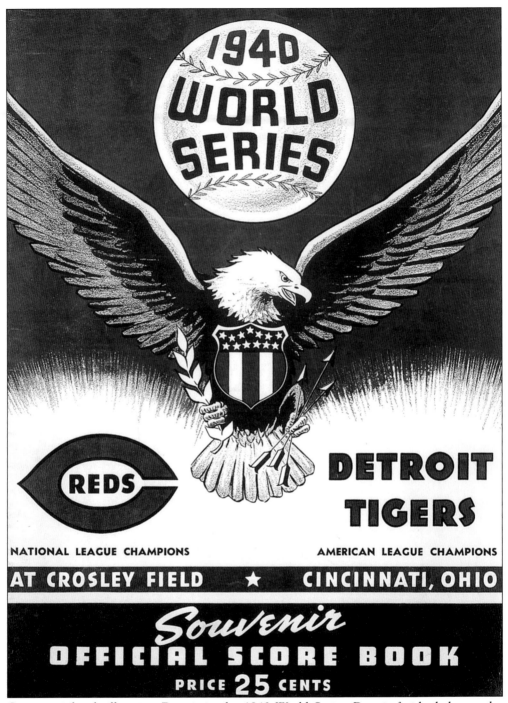

Cincinnati faced off against Detroit in the 1940 World Series. Detroit finished the regular season with a mark of 90–64, just one game ahead of the surprising Cleveland Indians. The Yankees were just off the mark as well, one game behind Cleveland. Bobo Newsom won 21 games for the Tigers, with Schoolboy Rowe adding another 16. Hank Greenberg hit for a .340 average, with 41 home runs and 150 runs batted in. It promised to be a whale of a series.

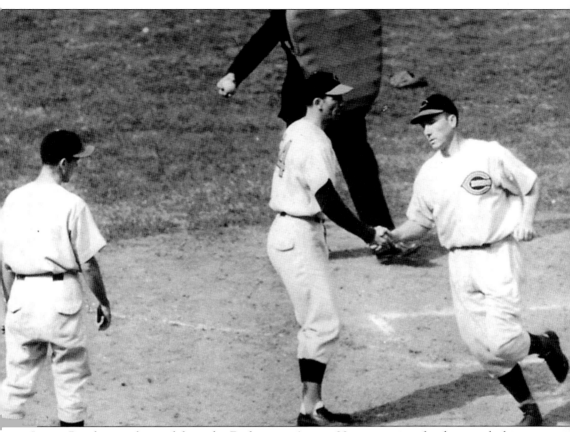

Jimmy Ripple was obtained from the Dodgers on August 23, just in time for the stretch drive for the pennant. He proved his worth in the Series, batting .333. In this image, he shakes the hands of teammates after hitting a second-inning homer in Game Two.

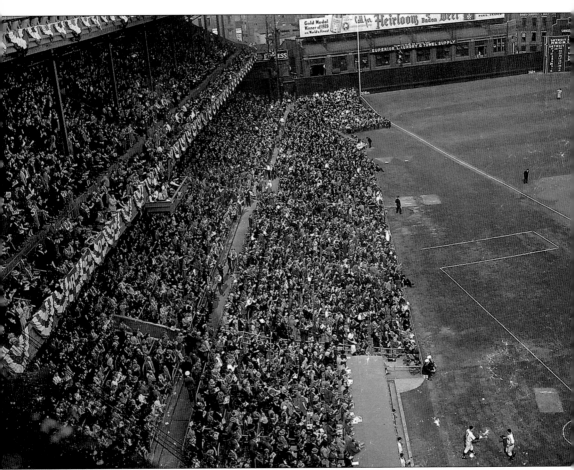

The patriotic bunting was out for the World Series, as this image shows of the stands down the third base line during Game Two. Bucky Walters was on the mound for the Reds and gave up two runs to the Tigers in the top of the first. However, the Reds tied it in the bottom of the inning and in the bottom of the third, went up 4–2 on a two-run homer by Jimmy Ripple. Ripple is shown being congratulated as he comes back to the Reds dugout after his blast into the right field bleachers. (Photo by Eugene Smith, courtesy of the University of Cincinnati.)

Tigers slugger Hank Greenberg greets commissioner Landis before the first game of the '40 series at Crosley Field. The Tigers took the first game, 7–2, as Bobo Newsom beat Paul Derringer. Greenberg was a hero to Jewish Americans who saw in him a living example of success in the sports world. For the first 50 years of the century, Jews would dominate the sports of boxing and basketball, but only seldom did they see achievement on the baseball diamond. After the beginning of World War II, Greenberg would become an even more important symbol in American Jewish life when he was one of the first major leaguers to enlist in the service and join the battle against Nazi Germany. (Photo by Eugene Smith, courtesy of the University of Cincinnati.)

Commissioner Kenesaw Landis died on November 25, 1944 after a quarter century in power. He was autocratic, arbitrary, thin-skinned, vengeful, filled with a sense of his own importance and his due destiny, and an obstructionist to integration. But no one doubted that when Organized Baseball needed a strong hand to set things right, that Landis had done so. For all his many faults, he did indeed love the game, and restored enough integrity to it to make Americans love it again as well.

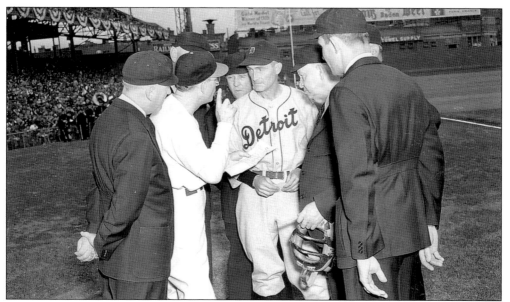

Cincinnati Reds manager Bill McKechnie goes over the Crosley Field ground rules with Tigers manager Del Baker and the umpires. Crosley, like most of the ballparks at the time, had some particular angles and features—such as the outfield terrace—that made it difficult for fielders who had never played on it. What constituted a home run on the outfield wall near the scoreboard also called for some explanation. (Photo by Eugene Smith, courtesy of the University of Cincinnati.)

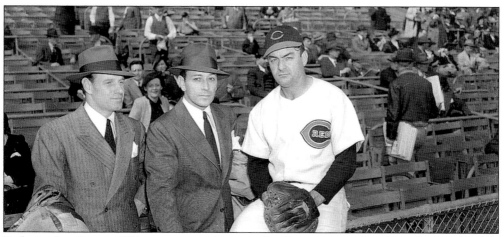

Reds catcher Jimmie Wilson poses with a couple of tough guys, Leo Durocher at the left, and actor George Raft in the center. Wilson was pretty tough himself as a ballplayer. He was coaching for the Reds after a major league career as a catcher, and took an active roster spot following Hershberger's suicide. After Ernie Lombardi severely sprained his ankle on September 15 the catching crew was nearly depleted so Wilson finished out the season and played the World Series. George Raft was known for his gangster films (and liked to dress the part, as did Durocher). Raft supposedly modeled his characters on real gangsters he had known while growing up in New York City's Hell's Kitchen, and once said that his movies taught real gangsters how to talk. As manager of the Brooklyn Dodgers, Durocher would be suspended by commissioner Happy Chandler for the 1947 season for consorting with gamblers. (Photo by Eugene Smith, courtesy of the University of Cincinnati.)

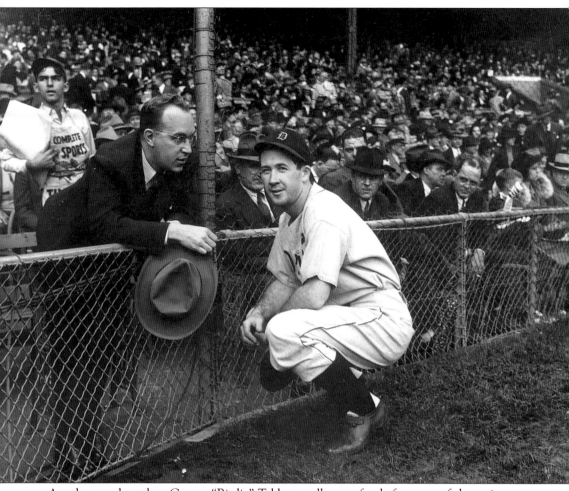

Another good catcher, George "Birdie" Tebbetts talks to a fan before one of the series games. Tebbetts got into four of the games during the series, but failed to get a hit in 11 at bats. Tebbetts would come back to Cincinnati to manage the Reds from 1954 to 1958. (Photo by Eugene Smith, courtesy of the University of Cincinnati.).

Another former Tiger who would also manage the Reds was pitcher Fred Hutchinson. A big righthander, Hutchinson played his entire career with Detroit, beginning in 1939 and finishing in 1953. For the World Series, he only got into one game and pitched one inning and gave up one hit. Hutch managed the Tigers and the Cardinals after his playing career was finished, and then managed the Reds from 1959 until his death from cancer in 1964.

The "Clown Prince" of baseball, former Major League pitcher Al Schacht created an on-field vaudeville routine once his playing days were over. Schacht threw for the Washington Senators from 1919 to 1921, but really made his mark as a coach. Discovering a flair for comedy, Schacht often paired up with former teammate Nick Altrock to entertain the fans before the game. By the late '30s, his new career was established. In this image he is seen with one of his props, an outsized mitt made for him by Cincinnati's Goldsmith Sporting Goods, one of the major manufacturers of the time that would later be known under the name of Hutch.

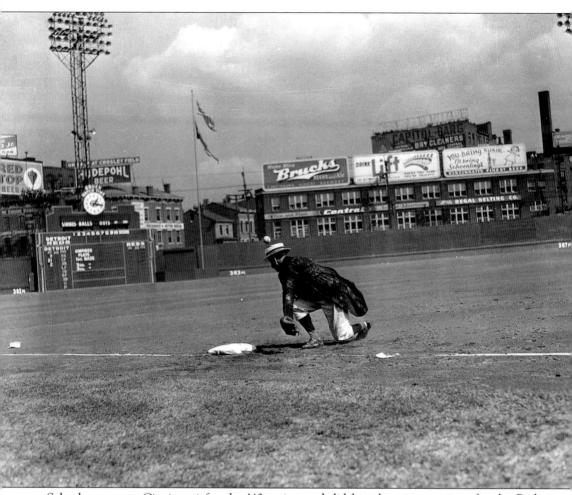

Schacht came to Cincinnati for the '40 series, and did his clowning routines for the Reds faithful before the first game. Performing into his 80s, Schacht is the ancestor for other baseball clowns like Max Patkin, the San Diego Chicken, and every other between-innings dugout-dancing, umpire-baiting, and kid-racing creature.

Reds fans had high hopes for the 1940 World Series. Sure, the Yanks had blown the Reds away the year before, but this current team was stronger, and had overcome injuries and tragedy to reach the fall classic. The top image shows the lines that formed as people waited for the ticket windows to open. In the bottom photo, the lucky fans that had front row seats behind home plate put their feet up and waited for the game to begin. (both photos by Eugene Smith, courtesy of the University of Cincinnati.)

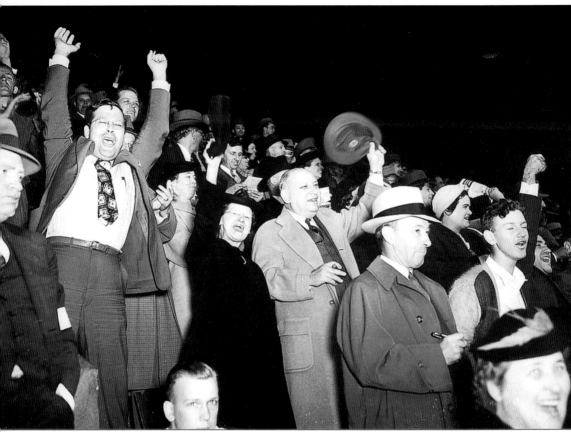

The fans in the stands react with joy in one image and dismay in another as the Reds battled the Tigers. Reds president Warren Giles, with cigar in one hand, brings another to his forehead as the

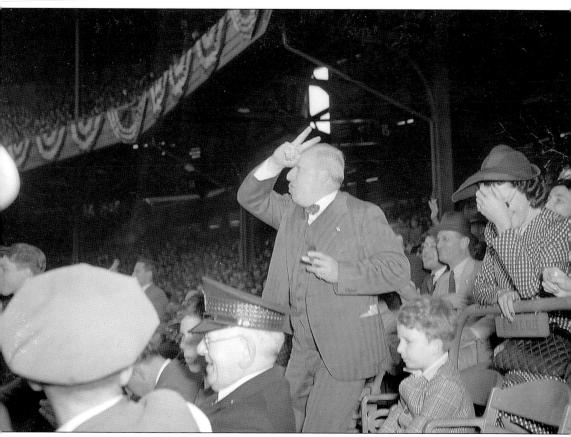

Reds allow a run. (Both photos by Eugene Smith, courtesy of the University of Cincinnati.)

But the Reds won out. On October 8, they clinched their first World Championship since 1919 with a dramatic 2-1 victory over the Tigers. Paul Derringer was the pitching hero, going the distance in the game. The winning run scored in the seventh inning on shortstop Billy Myers sacrifice fly to center field to score Jimmy Ripple. Afterward in the locker room, the Reds celebrated the hard-fought victory. Jimmie Wilson (center) hit .353 (not bad for an old man) in the series, his last games as a player. That November he accepted the manger's job with the Chicago Cubs. (photo by Eugene Smith, courtesy of the University of Cincinnati.)

The city of Cincinnati went crazy. Crowds of people flocked downtown to Fountain Square and neighboring streets to celebrate. Confetti and streamers rained down to the ground below the office windows.

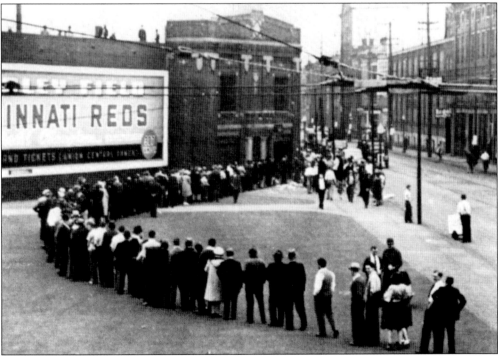

The next year, Reds fans anticipated another great season for the Reds, and they lined up to get tickets for the games. However, despite great hitting and fielding from first baseman Frank McCormick, and some sterling pitching from Vander Meer and rookie Elmer Riddle, the Reds finished in third place, 12 games behind Brooklyn.

The season began in traditional fashion, with the Findlay Market Opening Day Parade. A part of Cincinnati's heritage, Findlay Market had been operating with its stalls of fruits and vegetables, its fresh sausages, cheeses, and breads, since 1852. Fred Emmert of the market's association, stands to the right of a plaque presented to Bill McKechnie in recognition of the 1940 championship.

In a ceremony a few weeks later, Frank McCormick, who won the National League Most Valuable Player award, accepts the gift of an automobile from James Garfield Stewart, the mayor of Cincinnati, who stands to his left. Reds president Warren Giles is at McCormick's right as the first baseman takes a microphone to thank the fans.

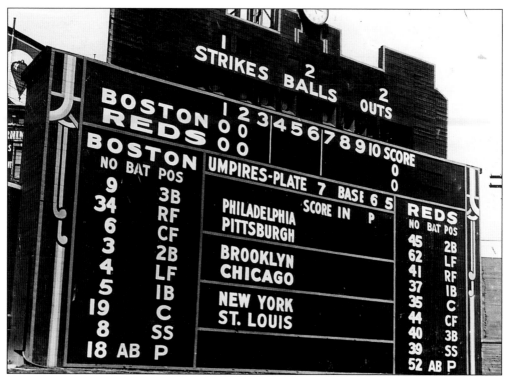

In 1942, the public address system at Crosley Field came under a bit of scientific scrutiny. University of Cincinnati engineering student Henry McKenney wrote his senior thesis on improving the sound at the ballpark. McKenney noted that the normal noise level at Crosley was in the 55–70 decibel range. Studying the placement of everything from the seating to the scoreboard, shown here, the student looked at blueprints of the field and acoustic drawings and concluded that the best reproducer of speech in the public address system would be a "pressure-operated dynamic microphone."

With war coming after the season's end, the Reds headed into 1942 not knowing what shape their team would take. For Powel Crosley's part, he placed notices in the Reds programs detailing the war effort being undertaken by his factories and employees. Even the baseball took a hit during the war. Because there were rubber shortages due to the war effort—as there were shortages of such things as gasoline, sugar, and leather—the composition of the baseball was switched to balata, a rubber-like substance, but definitely something that decreased the liveliness of the ball.

The Reds sent several players off for the war, either as fighting men or in war-related industries like shipbuilding and munitions. Twenty-seven players from their minor and major league rosters went into the service, including such stars as Ewell Blackwell, Johnny Vander Meer, and Hank Sauer. It opened an opportunity for another ballplayer, teenager Joe Nuxhall, shown in the bottom photo with Manager McKechnie. Spring training in '44 was held at Indiana University because of restrictions on wartime travel. In their public relations release that spring, the Reds said that of the players who reported, not among them was "Joe Nuxhall, the 15-year-old pitcher from Hamilton, Ohio, signed by the Reds. He will not report until the close of his school year in June." His debut was on June 10 against the Cardinals. The game was a blowout as the Cards were leading 13-0. Nuxhall walked five and give up two hits in less than an inning. That was his only appearance in a major league game until he made the Reds for good in 1952.

★ ★ ★

FROM THE FIELD

Bobby Adams	Ray Lamanno
Frank Baumholtz	Clayton Lambert
Ewell Blackwell	Mike McCormick
Leonard Bobeck	Ken Polivka
George Burpo	Jim Prenderghast
Jack Cassini	"Hank" Sauer
Worthington Day	Cecil Scheffel
Mike Dejan	Mike Schultz
Wilson Francis	Eddie Shokes
Linus Frey	Gene Thompson
"Hank" Gowdy	Johnny Vander Meer
Bert Haas	Clyde Vollmer
Millard Howell	Dick West
Ben Zientara	

FROM THE OFFICE

Fred Fleig	Charles Morris
Fred Hunter, Jr.	John Murdough
Frank C. Lane	Gabriel Paul

★ ★ ★

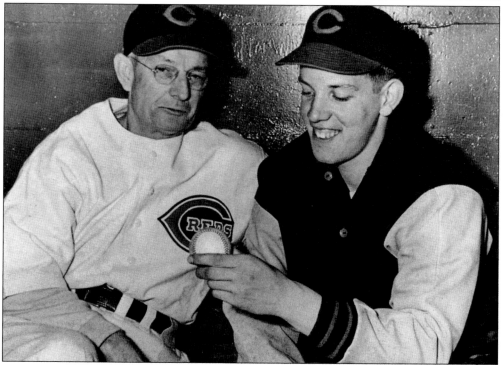

Pitcher Bob Ferguson was another one of those players who got a shot in the Major Leagues that they might otherwise not have received if it wasn't for World War II. The tall reliever appeared in only nine games with the Reds in '44, compiling a record of 0-3, with an earned run average of 9.00. After the season, he never pitched in the big leagues again. At the time, the oldest player on the roster was Estel Crabtree, who split his time between coaching and playing the outfield, and was termed a "pinch hitter de luxe." Ten players had 4-F classifications.

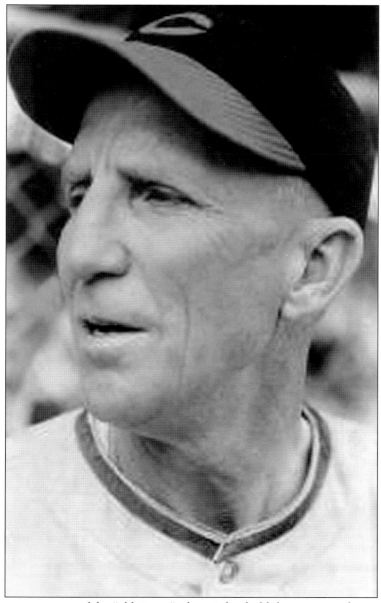

During the war years, one of the "old timers" who tried to hold the team together—almost with spit and baling twine in order to make a competitive roster—was coach Hank Gowdy. Gowdy had a long career in the National League with the Giants and the Braves until it ended in 1930, and he coached for the Reds from 1938 to 1942, and again from 1945 to 1946.

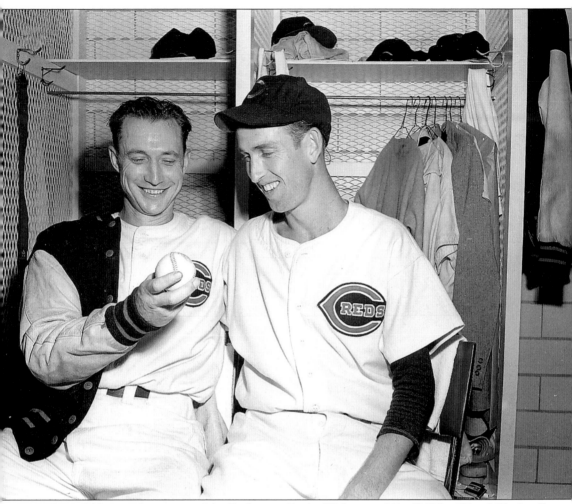

In a clubhouse photo, two of the Reds aces, Bucky Walters and Ewell "The Whip" Blackwell either smile at Walters' grip, or there's something funny on the ball. They first teamed together in 1942, but Blackwell only got into two games that year, with an 0–0 record. However, in 1947 Blackwell had his best year with a 22–8 mark, along with a streak of 16 straight victories. He also led the league with 193 strikeouts and 23 complete games. By '47, Walters was past his prime and would only garner eight wins, the last victories of what had been a very good career. Blackwell got his nickname because his body resembled a whip, especially when he went into his pitching motion.

The Reds were participants in one of the stranger cases of umpire-directed animosity in baseball history. On September 16, 1940 before a Sunday crowd, Cincinnati was in Brooklyn to play the Dodgers. George Magerkurth was the home plate umpire that day. In the top of the 10th inning, the Dodgers went to turn a double play on the Reds. On the play at second base, the umpire, Bill Stewart, called the sliding runner out, but Magerkurth overruled him when he saw the ball drop. Nothing more was thought of the call until the end of the game when everyone was leaving the field. Suddenly a short, fat fan named Frank Gernano ran up to Magerkurth, tackled him and began pummeling him. The fan didn't know who he was messing with. Magerkurth was a belligerent umpire, to say the least, and had had more than his share of run-ins with players and managers. He was six feet-three, weighed over 250 pounds, and had boxed and played football professionally. Police finally pried the two apart, with the fan about to get the worst of it. As it turned out, it was all a diversion. Gernano was an ex-con on parole, and he had a friend in the stands who used the attention-getting fistfight to pick a few pockets. The Reds won the game 4–3, and continued their road trip to Philadelphia before they clinched the pennant.

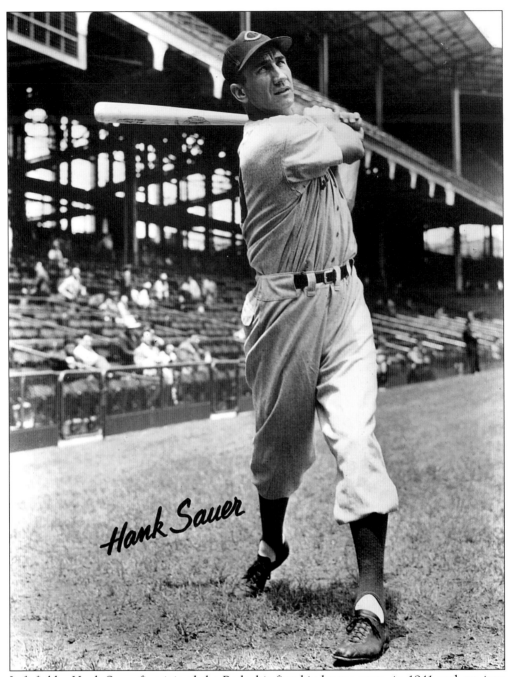

Left fielder Hank Sauer first joined the Reds, his first big league team, in 1941 and got into nine games. He played sparingly until 1948 when he became a starter, hitting 35 homers and knocking in 97 runs. The next year, however, the Reds dealt him to the Cubs, where he established his reputation as one of the National League's premier power hitters.

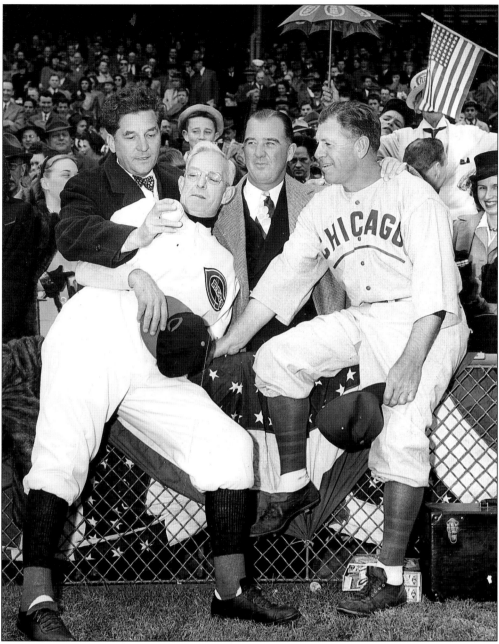

On Opening Day for the 1946 season, the pre-game festivities at the ballpark included a photo opportunity for Ohio governor Frank Lausche, holding a baseball in front of Reds skipper Bill McKechnie. They were joined by former Kentucky governor and the Commissioner of Baseball, A.B. "Happy" Chandler, standing beside Lausche. Cubs manager Charlie "Jolly Cholly" Grimm looks on. Before a Crosley crowd of over 30,000 fans, however, the game was not an auspicious start for the season. Despite Reds hurler Joe Beggs carrying a one-hitter through the eighth inning, the Cubs won the game 4–3. The Reds finished in sixth place that year with a record of 67–87, and near the end of the season, McKechnie resigned. (Photo by Jack Klumpe, courtesy of the University of Cincinnati.)

This view is of Cincinnati's streetcars picking up the fans after an afternoon game in the 1940s. Even at this point in the city's history, public transportation still carried a great many fans to Crosley Field. However, with social changes that happened after World War II, and "white flight" to the suburbs, more and more Reds followers drove to the ballpark in their own cars. The West End neighborhood continued to deteriorate, and safe automobile parking was hard to come by. The parking factor was another argument for the Reds to seek a new stadium in larger surroundings.

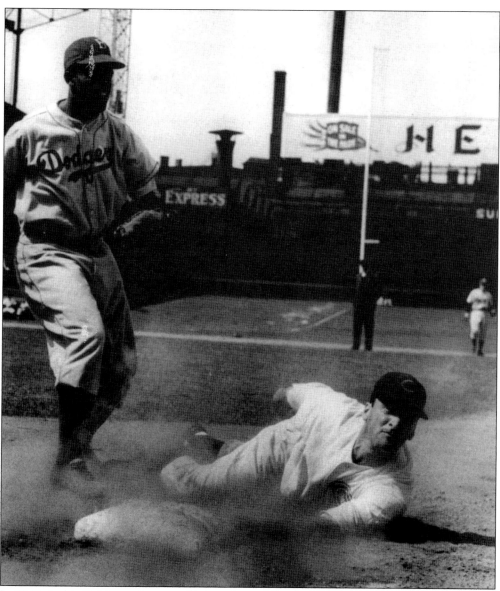

In 1947, Jackie Robinson integrated Major League Baseball in the modern era when he made the roster of the Brooklyn Dodgers after a year in the minors. Since the 1880s, an unofficial Jim Crow agreement among baseball's owners kept African Americans off Major League teams. However, in the post World War II era, the American military was desegregating and a civil rights movement was gaining steam in desegregating other segments of American society. With Kenesaw Mountain Landis dead and his obstructionist policies no longer the "law," Dodgers president Branch Rickey enlisted the support of new commissioner Happy Chandler to obtain Robinson from the Kansas City Monarchs of the Negro Leagues. This image is of Robinson playing at Crosley Field for the first time on May 13. Cincinnati, culturally a Southern city in many ways, attracted thousands of African American fans from the South who rode the trains to nearby Union Terminal in order to see Robinson play.

Reds owner Powel Crosley may have made his fortune in radio and small appliances, but his passion was for what he could bring to the automobile industry. Having begun his career in automobile parts and accessories, by the late '30s he was deeply involved in the quest to make small, solid, affordable cars. He formed Crosley Motors Incorporated, and established the main office and engineering facility in Cincinnati, where the motors were also assembled. The cars were fully assembled at a Crosley plant in Marion and Richmond, Indiana. In 1939, the first car rolled off the assembly line and on to America's streets. With a dream to build the lowest-

priced car on the market, Crosley even sold the engines in hardware stores. The earliest cars were priced at $210, and by 1948, 29,000 Crosleys were manufactured. However, sales went down from there, and in 1952, production ended. In the first photo, Crosley stands with two of his convertibles in a parking lot, while in the second image, Cincinnati mayor James Garfield Stewart clambers out of a Crosley at the ballpark. No one can explain the hat. (Both photos by Jack Klumpe, courtesy of the University of Cincinnati.)

Ted
Kluszewski

In the late '40s, the Reds received a power boost with the addition of Ted Kluszewski to the roster. Coming out of Indiana University, Big Klu played in nine games for the 1947 club, and by the next year was the regular first baseman. He added a lot of sock to a team headed for the home run-heavy '50s. Klu was renowned for his massive biceps that required him to cut off his uniform sleeves to get more freedom of movement. He played for the Reds from '47 through 1957, and later joined the Big Red Machine in the '70s as a coach. Over his 15-year career, Kluszewski belted 279 home runs.

Renowned urban planner Ladislas Segoe was brought in by the Cincinnati Planning Commission as a general consultant for its 1948 Master Plan. Segoe foresaw the tremendous urban changes that increase automobile use would bring about in the decades ahead, and much of his planning centered on accommodating cars and trucks, while still maintaining the quality of life through parks and recreational areas. As early as 1925, city planners discussed a ballpark on the river front, and the 1948 plan echoed the thinking behind it—that as population increased and traffic became heavier, there needed to be an easily accessed central location. Considerable debate was given to where a new Reds ballpark should go—the central business district, the suburbs, or even rebuilding Crosley in the West End. Eventually, much of Cincinnati's urban planning followed the '48 studies, and by 1970 the Reds would call River front Stadium their home.

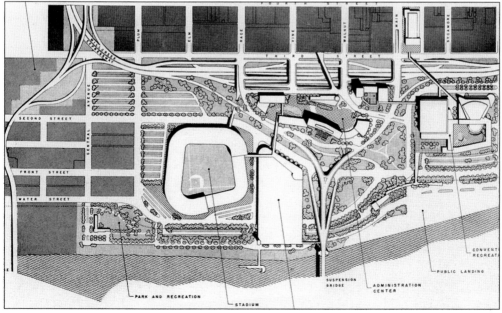

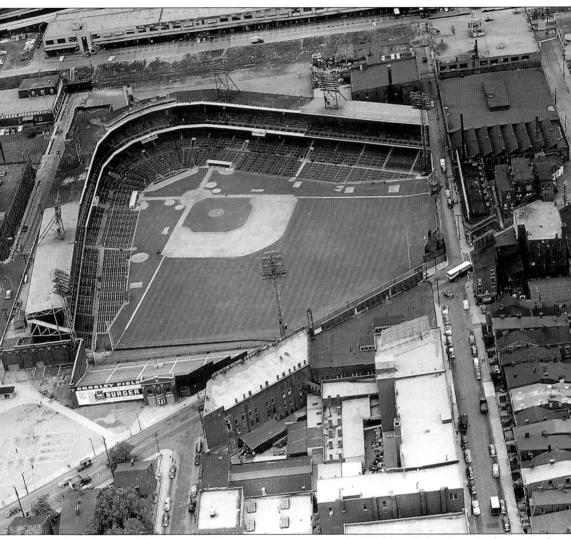

Until the new ballpark would be built, however, Crosley Field and the West End remained the home of the Reds. The neighborhood changed in the 1950s. More of the rowhouses and businesses were demolished to build additional parking lots, and the bisecting of the neighborhood by Interstate 75 provided additional quick access for fans from around the city and beyond in Reds country. Still, safe parking was still at a premium, and the old ballpark continued to deteriorate. The city of Cincinnati and the Reds were realizing the same decline in the physical plant and the neighborhood that other owners faced in their cities. The next decade would see a resurgence in the Reds that eventually led to the final World Series appearance in Crosley in 1961.

Selected Sources

Burk, Robert F. *Never Just a Game: Players, Owners, & American Baseball to 1920.* Chapel Hill, NC: University of North Carolina Press, 1994.

The Cincinnati Commercial Tribune, 1890–1930.

The Cincinnati Enquirer, 1890–1950.

The Cincinnati Times-Star, 1890–1950.

Cleve, Craig Allen. *Hardball on the Home Front: Major League Replacement Players During World War II.* Jefferson, NC: McFarland & Co., 2004.

Ellard, Harry. *Base Ball in Cincinnati: A History. Cincinnati, OH.* Johnson Publishing Co., 1907.

Finoli, David. *For the Good of the Country: World War II Baseball in the Major and Minor Leagues.* Jefferson, NC: McFarland & Co., 2002.

Ginsburg, Daniel E. *The Fix is In: A History of Baseball Gambling and Game Fixing Scandals.* Jefferson, NC: McFarland & Co., 1995.

Goldstein, Richard. *Spartan Seasons: How Baseball Survived the Second World War.* New York, NY: MacMillan Publishing Co., 1980.

Grace, Kevin. "Sporting Man: Garry Herrmann and the 1909 Cincinnati Turnfest." Cincinnati Occasional Papers in German-American Studies, No. 3. Cincinnati, OH. University of Cincinnati, 2004.

Grace, Kevin. *Cincinnati on Field and Court.* Chicago, IL: Arcadia Publishing, 2002.

Harlow, Alvin F. *The Serene Cincinnatians.* New York, NY: E. P. Dutton Co., 1950.

James, Bill. *The Bill James Historical Baseball Abstract.* New York, NY: Villard Books, 1986.

Miller, Zane. *Boss Cox's Cincinnati: Urban Politics in the Progressive Era.* New York, NY: Oxford University Press, 1968.

Murdock, Eugene C. *Ban Johnson: Czar of Baseball.* Westport, CT: Greenwood Press, 1982.

Nathan, Daniel A. *Saying It's So: A Cultural History of Black Sox Scandal.* Urbana, IL. University of Illinois Press, 2003.

Pietrusza, David. *Lights On! The Wild Century-Long Saga of Night Baseball.* Lanham, MD. The Scarecrow Press, 1997.

Rader, Benjamin G. *American Sports: From the Age of Folk Games to the Age of Televised Sports, 5th ed.* Upper Saddle River, NJ. Prentice-Hall, 2004.
Rader, Benjamin G. *Baseball: A History of America's Game, 2nd ed.* Urbana, IL. University of Illinois Press, 2002.

Rhodes, Greg and John Snyder. *Redleg Journal: Year by Year and Day by Day with the Cincinnati Reds Since 1866.* Cincinnati, OH: Road West Publishing, 2000.

Riess, Steven A. *Touching Base: Professional Baseball and American Culture in the Progressive Era.* Urbana, IL. University of Illinois Press, 1999.

Riess, Steven A. *Sport in Industrial America, 1850–1920.* Wheeling, IL. Harlan Davidson, Inc. 1995.

Riess, Steven A. *City Games: The Evolution of American Urban Society and the Rise of Sports.* Urbana, IL. University of Illinois Press, 1989.

Silberstein, Iola Hessler. *Cincinnati Then and Now.* Cincinnati, OH. The League of Women Voters, 1982.

Sullivan, Dean A., ed. *Middle Innings: A Documentary History of Baseball, 1900–1948.* Lincoln, NE. University of Nebraska Press, 1998.

Sullivan, Dean A., ed. *Early Innings: A Documentary History of Baseball,* 1825–1908. Lincoln, NE: University of Nebraska Press, 1995.

2003 Inaugural Season: Cincinnati Reds 2003 Media Guide. Cincinnati, OH. The Cincinnati Reds, 2003.

Wheeler, Lonnie and John Baskin. *The Cincinnati Game.* Wilmington, OH. Orange Frazer Press, 1988.

White, G. Edward. *Creating the National Pastime: Baseball Transforms Itself, 1903–1953.* Princeton, NJ. Princeton University Press, 1996.

Images for this book are from the author's collection; the Urban Sports Research Collection; and the Jack Klumpe Collection, and the Eugene Smith Collection from the Urban Studies Archives, Archives & Rare Books Library, University of Cincinnati.